ON THE COVER: Organized in 1909, the Amory Concert Band performed at the Amory Opera House and other venues around town. The band was captured in this 1915 photograph before a performance in Amory. The members of the band are not identified. (Courtesy of Amory Regional Museum.)

IMAGES of America
AMORY

Bo Miller and Sue Brown

Copyright © 2014 by Bo Miller and Sue Brown
ISBN 978-1-4671-1288-8

Published by Arcadia Publishing
Charleston, South Carolina

Printed in the United States of America

Library of Congress Control Number: 2014941891

For all general information, please contact Arcadia Publishing:
Telephone 843-853-2070
Fax 843-853-0044
E-mail sales@arcadiapublishing.com
For customer service and orders:
Toll-Free 1-888-313-2665

Visit us on the Internet at www.arcadiapublishing.com

We dedicate this book to the citizens of Amory—past, present, and future—for their generosity and support of the Amory Regional Museum.

CONTENTS

Acknowledgments		6
Introduction		7
1.	Cotton Gin Port	9
2.	Early Amory	15
3.	Schools and Churches	37
4.	Business and Industry	57
5.	The Community	101
6.	The Gilmore Legacy	117

Acknowledgments

We would like to offer our thanks to the people of Amory who have given their photographs and artifacts to the Amory Regional Museum. Because of their interest in preserving the history of Amory and north Monroe County, the museum has been able to collect and archive a wonderful collection of historical Amory memorabilia.

Unless otherwise noted, all images appear courtesy of the Amory Regional Museum.

The Amory Regional Museum was opened in 1976 with the mission to chronicle, archive, and curate the history of Amory and north Monroe County. If you would like to make a donation to the Friends of the Amory Regional Museum, please send it to 801 Third Street South, Amory, Mississippi, 38821. The museum is open Tuesday to Friday from 9:00 a.m. until 5:00 p.m.; Saturday from 10:00 a.m. until 4:00 p.m.; and Sunday from 1:00 p.m. until 5:00 p.m. Admission is free. All of the authors' royalties from the sale of this book will benefit the Friends of the Amory Regional Museum.

Coauthor Bo Miller (left) currently serves as director of the Amory Regional Museum, a position he has held since 2008. Coauthor Sue Brown (right), the museum archivist, has been serving the museum since 2006.

Introduction

Cotton Gin Port, Mississippi, the first white settlement in the northern part of the state, was incorporated by the Mississippi legislature in 1836, but the area had long been the economic hub of the region. It was the northernmost navigable point on the Tombigbee River and was the southern terminus of Gaines Trace. Cotton Gin Port was a busy, thriving trading post for the Chickasaw Indians, who occupied a series of villages on the west side of the river that extended into present-day Lee and Chickasaw Counties.

It is widely believed that Hernando De Soto crossed the Tombigbee River near Cotton Gin Port on his expedition in the 1540s. It is also believed that Bienville, the French governor of Louisiana, visited the area in 1736 on one of his expeditions to explore the French territory. The first permanent resident of Cotton Gin Port was Levi Colbert, a prominent Chickasaw Indian, who built his home at Cotton Gin Port in 1814. Soon, the settlement took on the characteristics of a river town, with Jackson Street being the location of most businesses.

If there is one word that is associated with the city of Amory, it would be "railroad." The St. Louis–San Francisco "Frisco" Railroad is the very reason that Amory is even on the map. In 1885, Gen. George H. Nettleton of Kansas City, Missouri, with the help of Boston capitalists Harcourt Amory and Eugene V. Thayer, succeeded in buying the right-of-way necessary to construct what would become the Kansas City, Memphis & Birmingham (KCM&B) Railroad. The new railroad needed relay points between Memphis and Kansas City and Memphis and Birmingham. The relay point between Memphis and Kansas City was to be known as Thayer, and the relay point between Memphis and Birmingham would be known as Amory.

The KCM&B Railroad bought a large tract of land from Amanda Owen, more than 500 acres. The railroad then had the land surveyed and marked into lots. Three lots in the new town of Amory were donated to churches and one was donated for a school. On November 15–17, 1887, the remaining lots were sold off at auction. Many were purchased by citizens of Cotton Gin Port, who saw that the establishment of the railroad center would doom the river town to extinction. All of the businessmen at Cotton Gin Port and most of the other citizens moved to Amory, bringing all of their possessions. Some moved their buildings, rolling them to town on logs, while others built new buildings in Amory.

The first election in Amory was held on February 22, 1888. J.W.C. Wright was elected the first mayor. Also elected as aldermen were R.P. Dilworth, James A. Mayfield, John D. Collins, and Will Berry. The aldermen selected William Singleton as the town marshal. With town officials in place, the Town of Amory was granted incorporated status on March 20, 1888. The first business to open in the new town was the store of James A. Mayfield, in a building rolled to Amory on logs from Cotton Gin Port. Located on Main Street, the store carried clothing for men and women as well as general merchandise.

Railroad men and businessmen soon realized that no town would be permanent unless it was built around churches and a school. The First Christian Church was moved to Amory from Cotton Gin Port and located on one of the lots donated by the railroad. The first school building

erected by the town was a four-room frame building located on the present-day site of the First Presbyterian Church. That school building served the community until it was replaced with a larger building in 1908.

Agriculture has always played an important part in the economy of Amory. But, as Amory grew, so did the opportunities for new businesses and industries. Men such as E.D. Gilmore and Archibald Dalrymple were instrumental in the growth and progress of Amory. W.A. Lea, Lucien Owen, and J.W. Holloway, along with other businessmen, opened businesses that made Amory a center of commerce for the area. Because the growth of Amory was tied to the railroad, the town fared better than most communities when economic troubles did occur.

Amory attracted other types of industry as well. Men like Ike and Tommy Longenecker, Coy Glenn, Frank Page, and others brought the garment industry to town and eventually Amory became known as "The Pants Capital of the World." During the peak of the garment industry here, every pair of men's pants sold by Sears, Roebuck & Co. was made in Amory. Businessmen like E.C. Bourland, J.R. Scribner, Erbie Lee Puckett, Tom Cole, and others drove the economic progress of Amory for years.

The Gilmore Sanitarium was the first hospital in the area and eventually became Gilmore Memorial Hospital. The hospital has grown into Gilmore Memorial Regional Medical Center and provides quality health care for northeast Mississippi and northwest Alabama. In the 1960s, True Temper and Cramco selected Amory to be their home.

Despite the ups and downs that face any city, the people of Amory have always been very proud of their city and proud to call it home. The people of this community have made, and continue to make it, a warm, caring, wonderful, Southern town.

The photographs in this book give just a small glimpse of the history of Amory. There could have been hundreds more photographs selected for publication. Please enjoy this trip back in time.

One

Cotton Gin Port

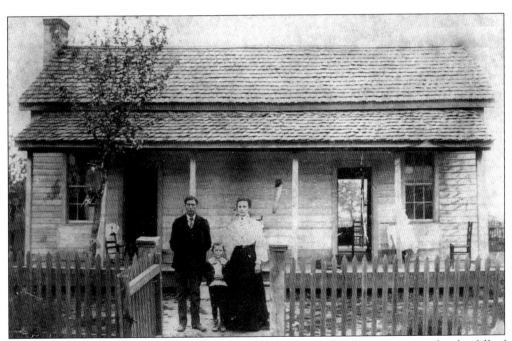

Cotton Gin Port, Mississippi, settled in 1814, had become a bustling river town by the fall of 1887. The port was as far north as is navigable on the Tombigbee River and served as a center of commerce for the region. Cotton and livestock were the main trade items of the day, and were shipped by riverboat down the Tombigbee to Mobile. Store owners would visit Mobile to stock their stores and buy groceries. The town also served as a trading post for the Chickasaw Indians, who lived right across the river to the west. After the Indians were relocated along the infamous Trail of Tears in the late 1830s, the town of Cotton Gin Port survived, but it hardly flourished. As Columbus and Aberdeen began to grow and prosper, Cotton Gin Port lost its position as the center of trade for the region. In the fall of 1887, with a maximum population of about 250, word arrived that the Kansas City, Memphis & Birmingham Railroad would soon be establishing a new town three miles east, to be called Amory.

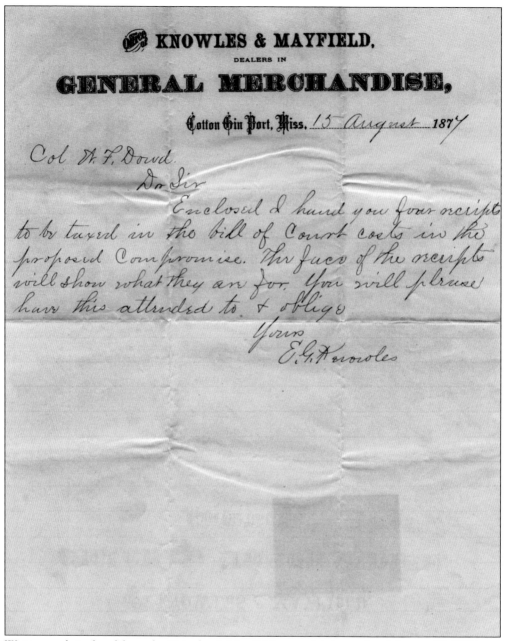

Written on letterhead from the Knowles & Mayfield store, this letter dated August 15, 1877, was sent from E.G. Knowles to Col. W.F. Dowd requesting his help in settling a legal matter.

This invoice from the 1870s shows that the Knowles & Mayfield store carried a variety of merchandise, including dry goods, groceries, boots, and shoes.

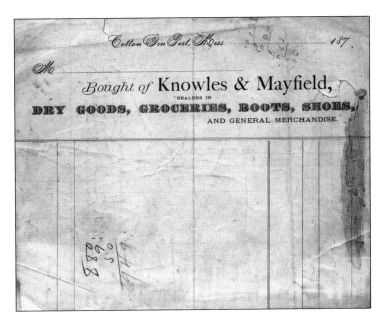

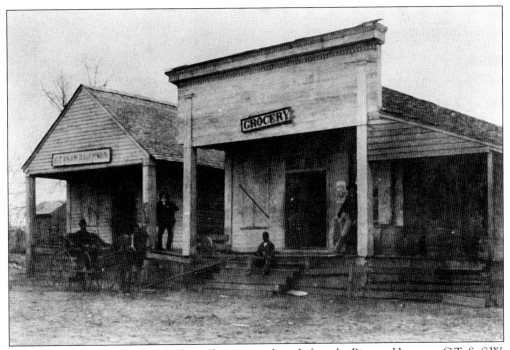

The town of Cotton Gin Port had a wide variety of goods for sale. Pictured here are G.T. & S.W. Williamson Dry Goods and a grocery store. Most of the merchants in Cotton Gin Port moved their businesses to the new town of Amory.

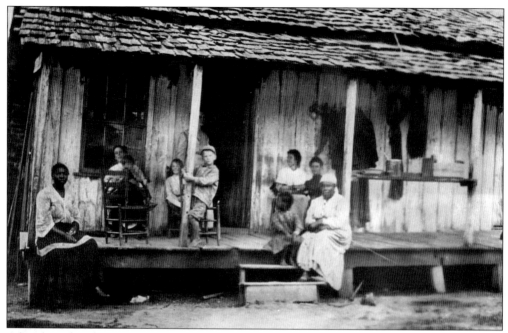

After the railroad came to nearby Amory, not much was left of Cotton Gin Port. This photograph from around 1889 shows a family that remained there. Tenant farmers and sharecroppers made up most of the dwindling population of the once bustling town.

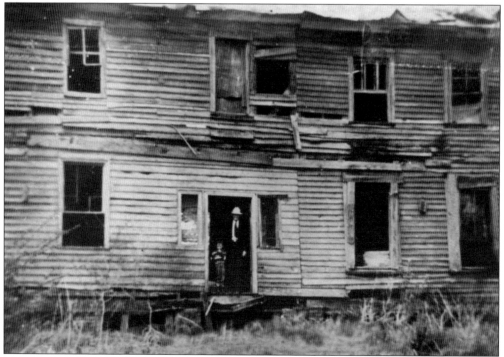

The Mayfield Hotel in Cotton Gin Port was built around 1840. The building was constructed with no nails. The entire structure was held together with wooden pegs. Since the building was not moved to Amory, it fell into disrepair and was eventually destroyed in the late 1890s.

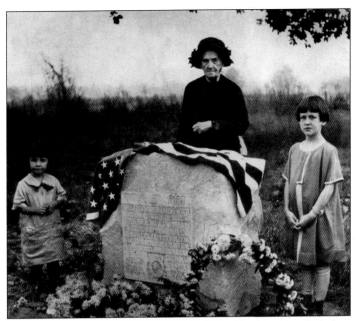

The Daughters of the American Revolution (DAR) Cotton Gin Port Chapter wanted to make sure that Cotton Gin Port would be remembered for the historical significance of the settlement. In this photograph, from left to right, Pat Mayfield, Nancy Williamson Dilworth, and Eleanor Rowan stand with the marker placed at Cotton Gin Port in November 1924. The marker commemorates Cotton Gin Port as the "earliest permanent white settlement in North Mississippi."

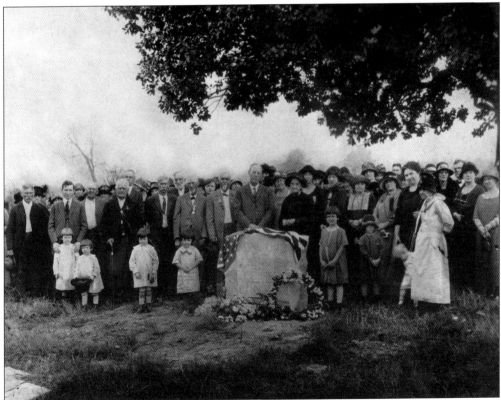

The placement and dedication of the DAR marker in November 1924 brought a large crowd to the site. Amory officials as well as other area dignitaries came to mark the occasion. The men at left center wearing badges are Civil War veterans. The women on the right are members of the DAR chapter.

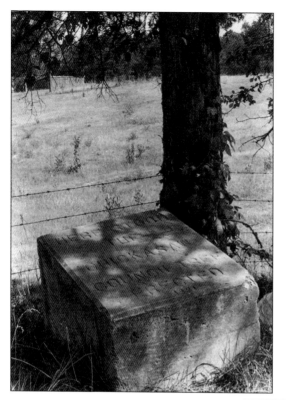

This is the marker that designates the place of the Chickasaw Council Tree. This marker was placed by the Cotton Gin Port Chapter of the DAR in 1921. As they were unsure of what exactly had happened there, the marker simply reads, "Here stood the Chickasaw Council Tree." It was long believed that the 1818 Chickasaw Treaty of Old Town was signed here, ceding all of Western Kentucky and Tennessee to the United States. The council tree was destroyed by a fire left by campers.

In the 1940s, the State of Mississippi started a program to mark historical sites around the state. Pictured here is the Cotton Gin Port marker, erected on October 27, 1949. The marker stands today approximately one mile north of Cotton Gin Port next to Highway 278 West.

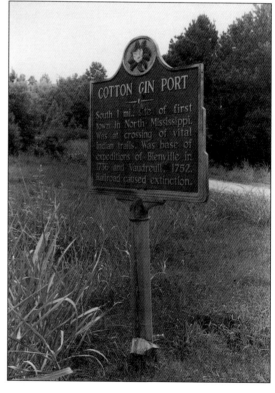

Two

Early Amory

Pictured here is Amanda Owen. She and her family sold the KCM&B Railroad 500 acres of land on which the new town of Amory was built. In her left hand, she is holding the deed to the town. In November 1887, the railroad auctioned off lots to the highest bidders. The new town drew businessmen such as E.D. Gilmore and Archibald Dalrymple, who became instrumental in the foundation of Amory. Most of the businesses at Cotton Gin Port were moved to Amory, which soon became a center of commerce for the region. New businesses opened up as the town began to grow and prosper. In the late 1890s, Amory was home to an opera house, two pharmacies, a lumberyard, several dry goods stores, an icehouse, three grocery stores, two hardware stores, and two hotels. The town would experience steady growth over the years, as the railroad expanded its operation and more businesses and people moved to town.

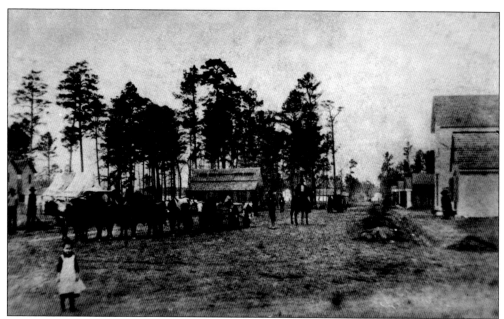

Amory quickly became a center of commerce for the people of the area. A variety of businesses drew people from near and far. This photograph shows Main Street looking north from what is now Second Avenue South. The area to the left is currently Frisco Park.

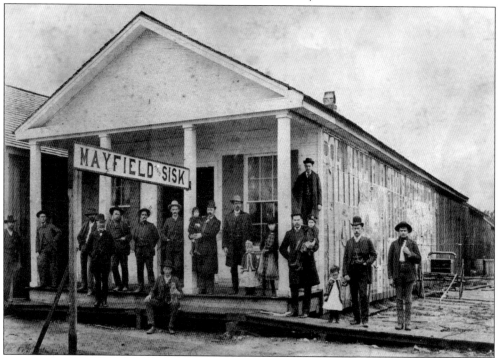

The Mayfield family was one of the earliest settlers at Cotton Gin Port. They operated a dry goods store there, and moved the business to Amory along with most of the other businesses in 1887. Pictured here is the Mayfield & Sisk store on Main Street in Amory. The man on the porch in the top hat holding a child is the proprietor, James A. Mayfield.

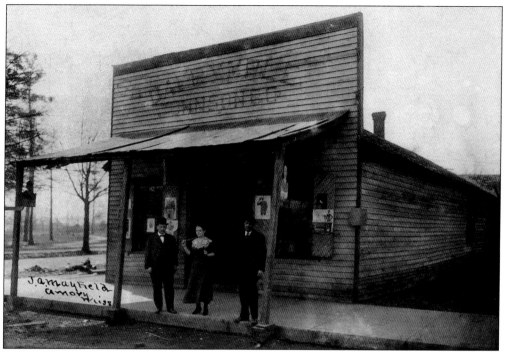

Pictured here is the Dalrymple Johnson dry goods store. This business was also moved from Cotton Gin Port to Amory. The man on the right is Sam Grady, who eventually became mayor of Amory and sheriff of Monroe County. This photograph is from around 1888.

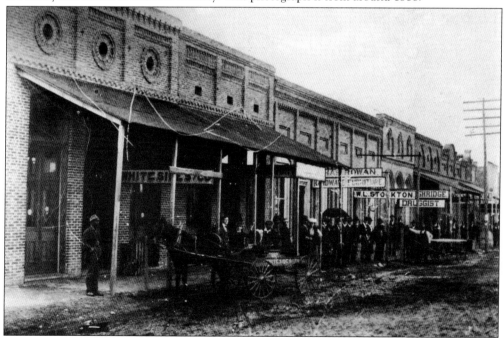

Main Street was the center of activity for the new town. In this photograph, a group of men pause in front of several of the businesses located there. Rowan Hardware, at center, operated in this location until the 1970s.

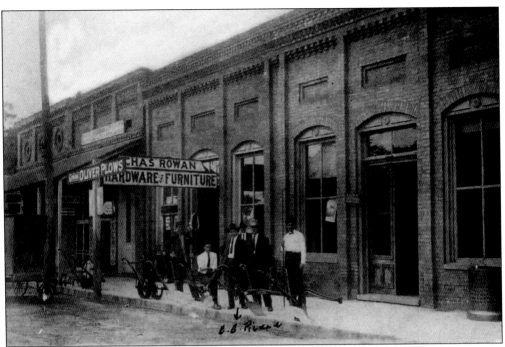

Rowan Hardware was also the local distributor of caskets. In this photograph, the man in the center is E.E. Pickle, who worked for Rowan Hardware for 19 years. Pickle eventually founded the E.E. Pickle Funeral Home in 1925. Today, the funeral home is owned by the fourth generation of the Pickle family.

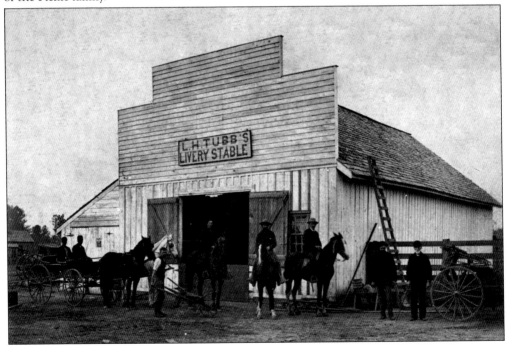

Pictured here is the L.H. Tubb Livery Stable, where horses could be boarded and carriages were available for hire.

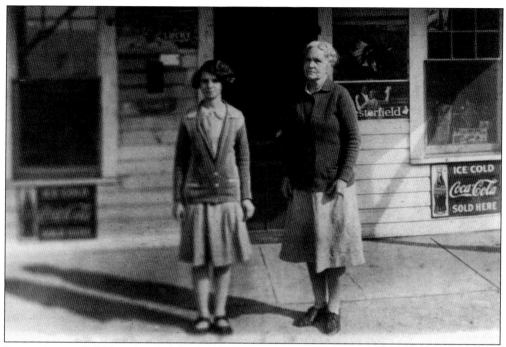

Pictured around 1920 in front of the family store in the small community of Darracott are Belle Burkitt and Nettie Daracott. The latter moved to Amory and operated a women's ready-to-wear store for many years. Darracott was the first female merchant in Amory.

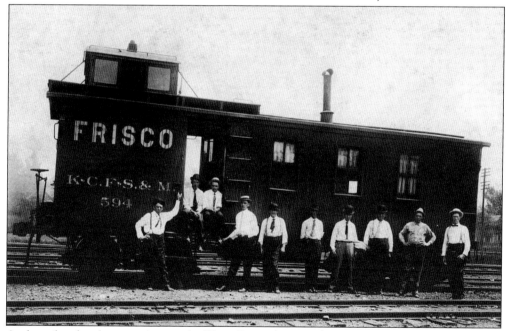

As the railroad took root in Amory, the "Frisco" name began to be seen more often. This photograph shows some local men posing with a Frisco caboose sometime in the late 1880s. Note that the caboose is marked with "K.C.F.S & M;" before it was the Kansas City, Memphis & Birmingham Railroad, it was named the Kansas City, Fort Smith & Memphis Railroad.

E.D. Gilmore was born in Itawamba County, Mississippi, in 1854. He moved to Amory in 1887 to seize some of the opportunities that the new town could offer. Gilmore was a devout Methodist and one of Amory's leading philanthropists. Among the businesses he founded were the Bank of Amory, the Gilmore Puckett Lumber Company, and the Amory Grocery Company. He even had a bottling company that made a product called Tenn Cola. Recognizing the need for medical care in the area, he and his wife, Virginia, built the Gilmore Sanitarium, which opened on December 1, 1916. One of the first hospitals in North Mississippi, it operated as Amory's hospital until January 1961, when the Gilmore Memorial Hospital was opened. The Gilmore Sanitarium building is now home to the Amory Regional Museum.

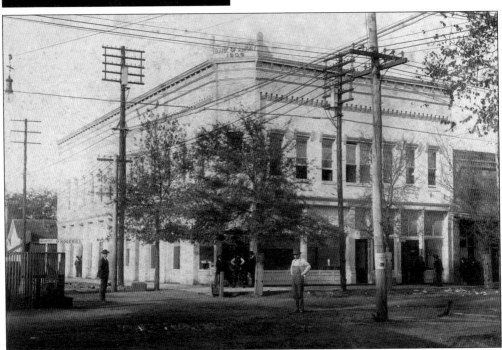

The Bank of Amory was founded in 1906 by E.D. Gilmore. The building is pictured here around 1907. The Amory Telephone Company was located on the second floor. The Bank of Amory was locally owned until the 1980s, when People's Bank & Trust Company bought control of it. The bank, now named Renasant, is still located in the building on the corner of Main Street and Second Avenue North. To the left is the entrance to the Amory Grocery Company, also founded by E.D. Gilmore.

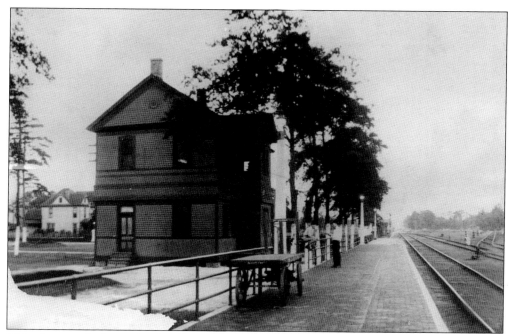

This photograph shows the first Frisco yard office. This building was the center of all railroad business conducted in Amory. The yard office stood on what is now Front Street and was the railroad headquarters until the Frisco built its office building, which served as the Southern Division headquarters in 1953.

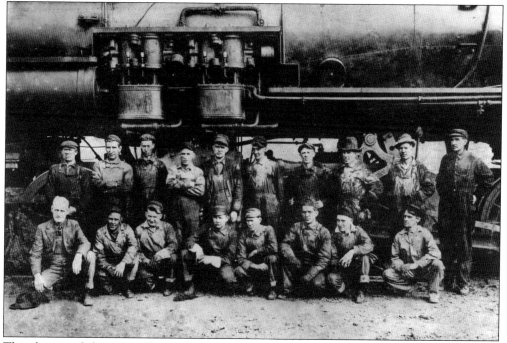

This photograph from around 1900 shows the group of mechanics who were responsible for keeping the Frisco locomotives operational. Most of these men were from Amory and worked for the railroad for many years. The railroad provided a stable income for working families in Amory.

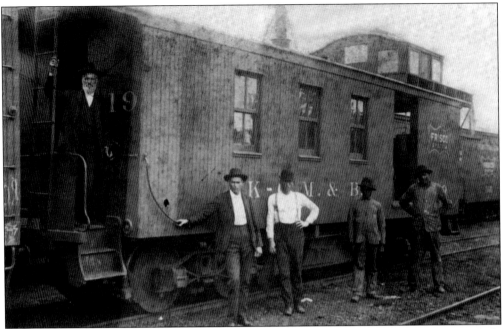

From left to right, Rev. K.M. Harrison (standing on caboose platform), conductor H.D. York, flagman W.P. Johnson, and brakemen West Jackson and Tom Scott posed for this photograph around 1895. Reverend Harrison was en route to Nettleton.

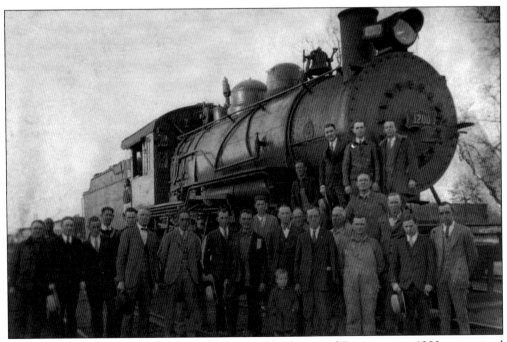

In January 1928, local businessmen and railroad officials greeted Frisco engine 1200 as it arrived in Amory. The people of Amory were aware of how important the railroad was to the growth and prosperity of the new town, and they made an effort to welcome it at every opportunity.

Dr. G.S. Bryan was one of the first doctors to set up practice in Amory. He practiced medicine here from 1889 until his retirement in the mid-1940s. He is pictured here with his beloved daughter Marilu Bryan Griffin. Dr. Bryan was a history buff and wrote several papers covering the beginning of Amory.

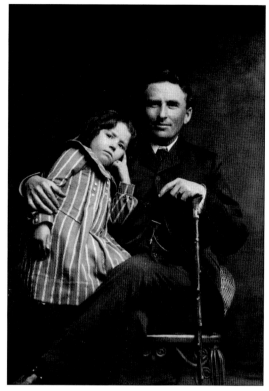

Recreational opportunities were rare in the new town. This group of citizens is pictured enjoying a boat ride and picnic on Malone Lake, north of Amory. Malone Lake was drained during the construction of the Tennessee–Tombigbee Waterway in the late 1970s. While draining the lake, the US Army Corps of Engineers found an Indian dugout canoe dating to the late 17th or early 18th century. The canoe has been preserved and is on display at the Amory Regional Museum.

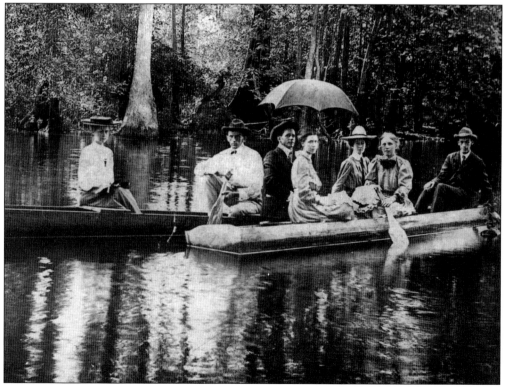

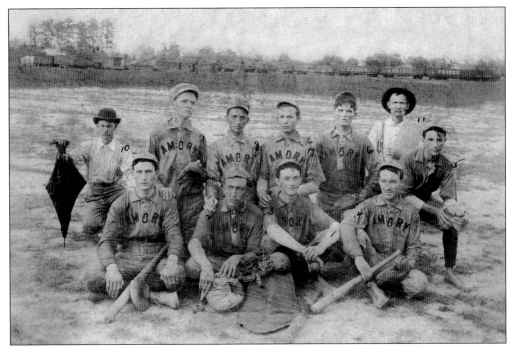

One of the first Amory baseball teams is pictured here around 1900. The team members are only identified by their last names. They are, from left to right, (first row) Gregory, Doggrell, Parker, and May; (second row) Harrison, Haughton, Willis, Webb, Grizzle, Clay, and Hall.

Duke's General Store was located on Main Street. The store operated from 1900 until 1940. These men, who are not identified, posed for this photograph around 1925.

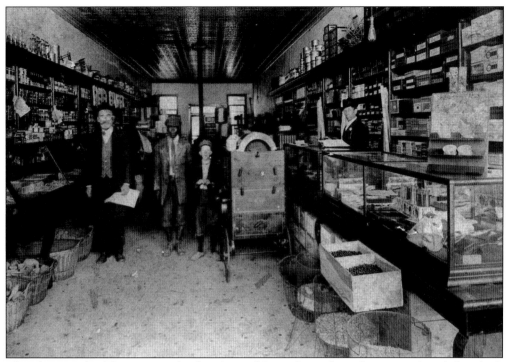

This photograph of the interior of Duke's General Store shows the wide variety of goods for sale. It was taken in the early 1900s, shortly after the store was opened. The people are not identified.

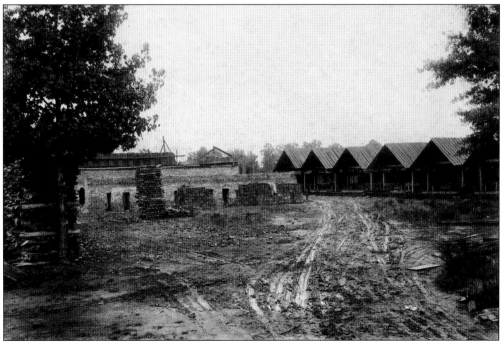

As brick homes and businesses became more popular, Amory was home to two brickyards. The Amory Brick Yard is pictured here in the late 1890s. It was located on the current site of McAlpine Lake in north Amory.

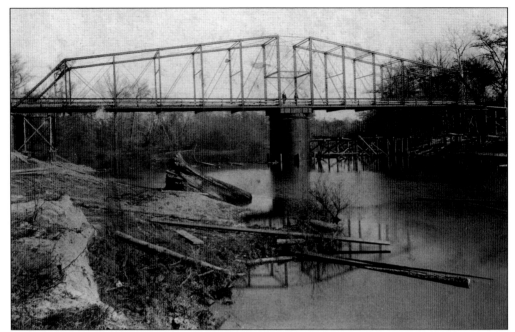

As Amory grew, the need arose for access to other nearby towns such as Nettleton and Tupelo, to the north. This is the newly completed bridge over the Tombigbee River at Bigbee in 1899. The bridge, which was one lane, was used by travelers until the completion of the Highway 6 Bridge in November 1959. (Courtesy of Evans Memorial Library Special Collections.)

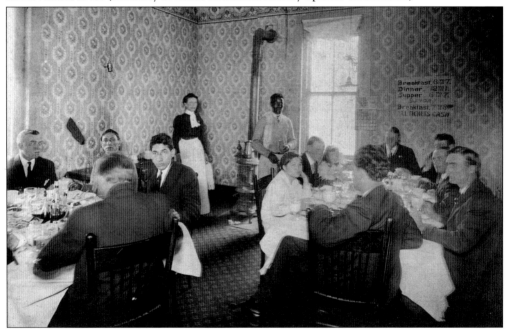

The Amory Hotel served three meals daily in its private dining room. Here, in the late 1890s, patrons are enjoying a meal while the waitstaff stands closely by. The sign on the wall states the meal times: "breakfast from 6 to 7, dinner from 12 to 1, supper from 6 to 7, and Sunday breakfast from 7 to 8." The sign also reminds diners, "All tickets cash."

In 1903, Amory's second bank opened under the name Merchants & Farmers Bank. It only operated for 10 years and was closed in 1913. However, no depositors lost any money when the bank folded. Almost immediately after this bank closed, the building and equipment were purchased and the Security Bank of Amory was opened in November 1913.

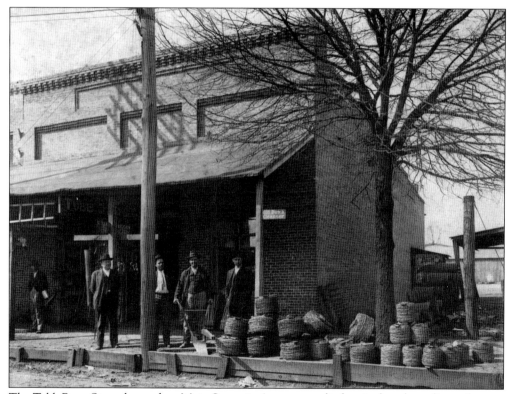

The Tubb Bros. Store, located on Main Street in Amory, supplied agricultural supplies to farmers in the area. In this photograph from the 1890s, there are rolls of barbed wire for sale. The men in front of the store are seen with a new plow. The Tubb family came to Amory from Cotton Gin Port.

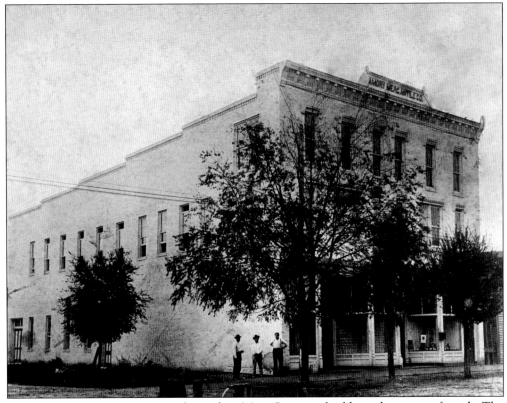

Amory Mercantile Company was located on Main Street and sold a wide variety of goods. The building also housed the Amory Opera House on the second floor. The opera house was host to plays and concerts by local citizens as well as traveling artists. This building stood at the corner of Main Street and Third Avenue North.

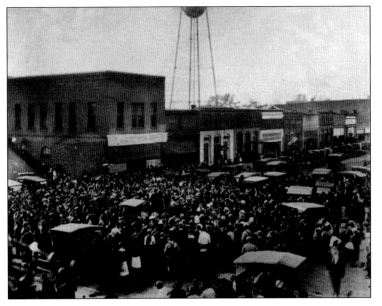

A crowd has gathered on Trade Days in the spring of 1924. Since Amory had become a center of commerce for the area, local merchants would entice people to town with giveaways, usually money, and area farmers would bring animals and produce to town to sell or trade. This photograph was taken at the corner of First Avenue and Main Street, across from Frisco Park.

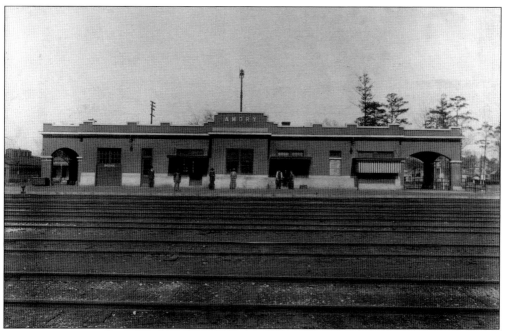

Amory's depot was the center of activity in the new town. Built in 1916, it was more active than most depots because it was a crew change station for the railroad and a connecting point for Frisco lines that ran south to the Gulf Coast. The building was torn down in 1968 as part of the revitalization of Amory through urban renewal.

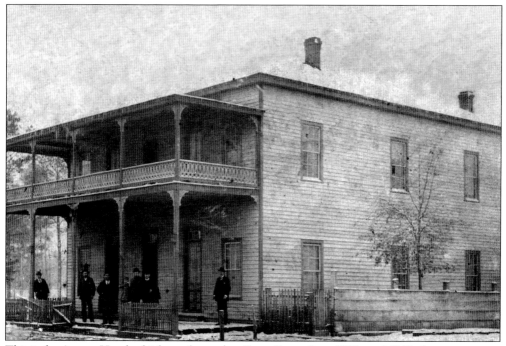

This is the Amory Hotel, which was located on Front Street from 1892 until 1900. As a connecting place for the railroad and a crew change station, Amory was home to three hotels that were close to the train station.

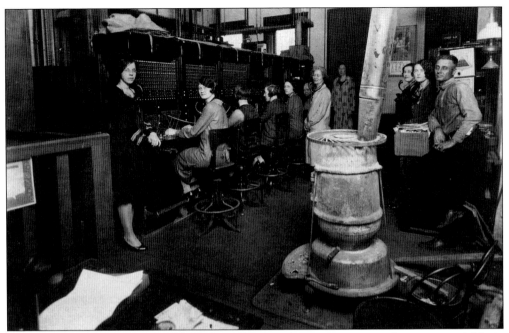

By the end of the 1890s, Amory had most of the modern conveniences that were available in larger towns. This is the Amory Independent Telephone Company, which was located above the Bank of Amory. The phone company remained in business until the 1940s, when it was purchased by Southern Bell.

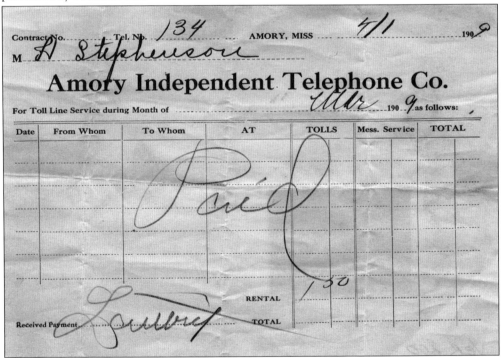

This receipt from the Amory Independent Telephone Company shows that there was a balance paid of $1.50 for telephone number 134 for service for the month of March 1909.

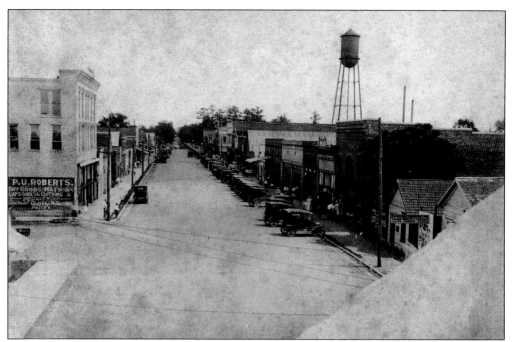

Here are two different views of downtown Amory around 1915. The photograph above shows a bustling Main Street looking south. This image was taken from near Vinegar Bend, just north of Third Avenue North. The building to the left housed the Amory Mercantile Company and the Amory Opera House. The photograph below shows an unpaved Main Street looking north. This photograph was taken from the corner of First Avenue and Main Street. On the right, buildings were still being constructed on Main Street. On the left is the J.A. Mayfield Store, one of Amory's first businesses.

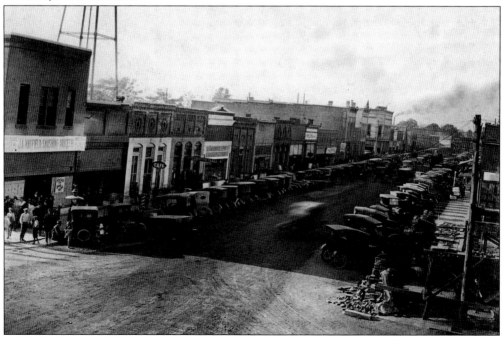

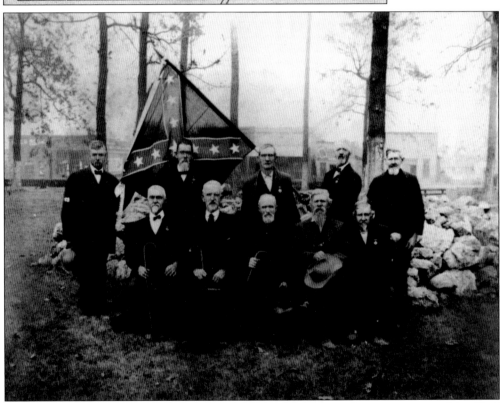

On January 31, 1903, W.M. Tubb paid his debt to the town in the amount of $1.93. Tubb was taxed on property that included six head of cattle, one horse, two mules, two wagons, and one watch.

This photograph from 1916 shows some of the surviving Monroe County veterans of the Civil War. From left to right are (first row) Jim Fears, R.M. Roberts, Bob Nabors, Cassary Ross, and W.M. Butler; (second row) W.M. Morgan, J.W. Kingsley, A. Armstrong, S.G. Morgan, and A. Stewart.

Pictured on the front porch of the new town hall around 1920 are, from left to right, J.O. Prude, Sam Cheek, Sam Grady, and James Mayfield. The young man in front is Mayfield's son Jimmy.

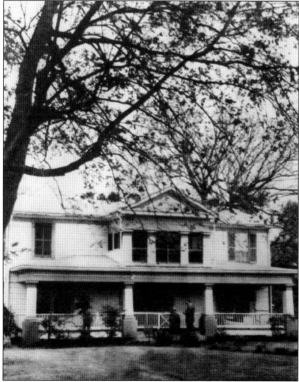

Myrtle Bower was the oldest home in Amory. It was built in 1849 and was the family home of Gertrude Haughton, who taught school for 40 years in Amory. In 1980, it became a group home for young men established by the Monroe County Youth Court Services. The house was destroyed by fire in the 1980s.

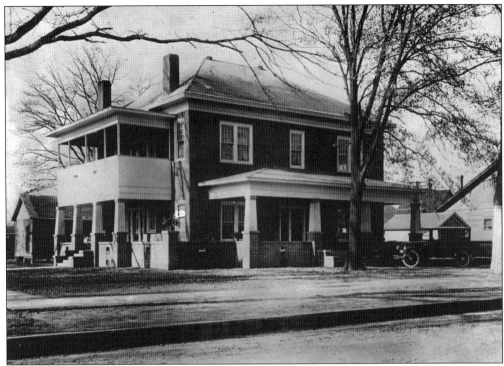

The James A. Mayfield home on South Main Street is seen here around 1920. The house was one of the first permanent structures built in the new town of Amory. The building has served not only as a family home, but also as a bank, real estate office, and lawyer's office over the years. It is currently a private residence. The small building to the rear was moved to Amory from Cotton Gin Port in 1887.

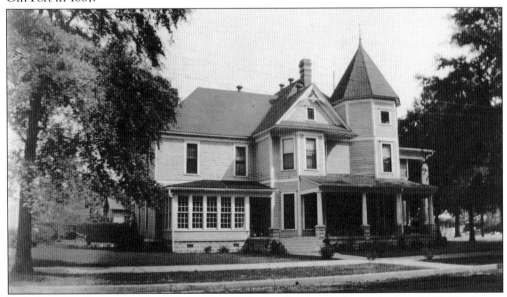

This photograph shows the home of E.D. and Virginia Bolding Gilmore, built in 1905. The house is a classic example of the Victorian architecture that was prevalent during the period. It is located at the intersection of Second Avenue South and Third Street South.

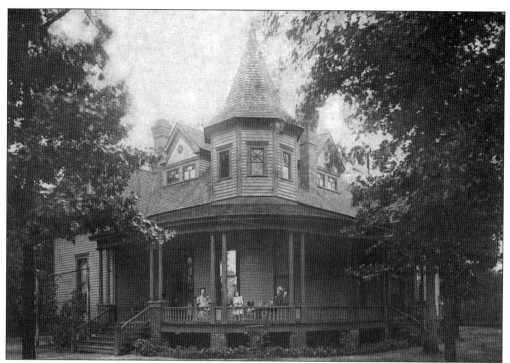

Also built in the Victorian style is the home of Dr. G.S. Bryan. Built in 1890, the house is located at 412 Fourth Street South. Dr. Bryan, one of Amory's first physicians, lived there until his death in 1964.

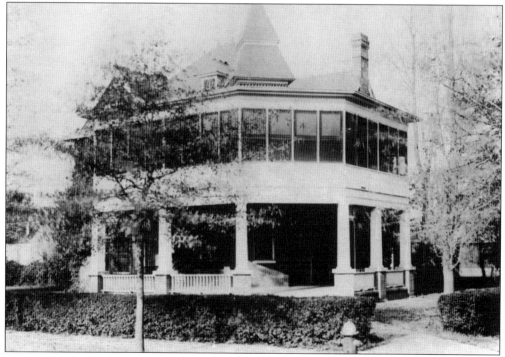

This is the first brick home constructed in the new town of Amory. Built with bricks made in Amory, the home still stands at the corner of Fifth Avenue South and Third Street South.

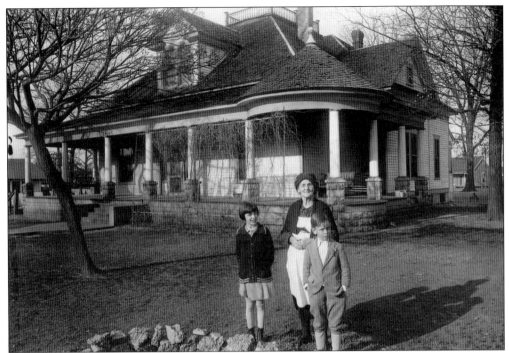

This 1930 photograph shows the family home of John Milton Norton. From left to right are Martha Jane Norton, Beadie Roper Webb, and John Wilson Norton. The house, built in 1909, is located at 411 Fifth Street South.

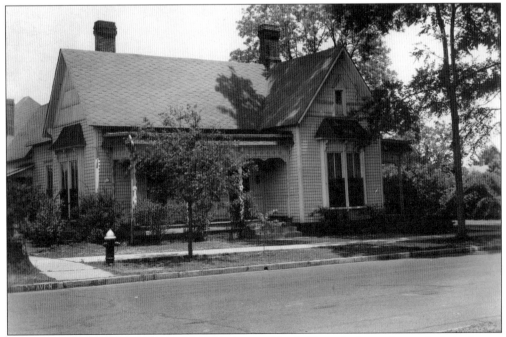

The Webb family home was located on Fifth Avenue North. Typical of many homes built in Amory around the turn of the 20th century, it was destroyed by fire in the mid-2000s. The Webb family was one of Amory's founding families, moving from Cotton Gin Port in the late 1880s.

Three
SCHOOLS AND CHURCHES

Since its founding in 1887, Amory has placed importance on two things: religion and education. The first school was started in 1888, and the first church was brought to Amory from Cotton Gin Port in 1887, when the town was founded. Amory is currently home to over 20 churches and a top-rated school district. This photograph shows Rev. M.H. Armour, who was pastor of the First Christian Church from 1890 until 1908. Reverend Armour is considered the first permanent minister in Amory. The congregation met in the original building that was moved from Cotton Gin Port until the 1920s, when a brick structure was built. Artifacts from the Cotton Gin Port Christian Church, including the silver communion service, pulpit, chairs, and Bible, are on display at the Amory Regional Museum.

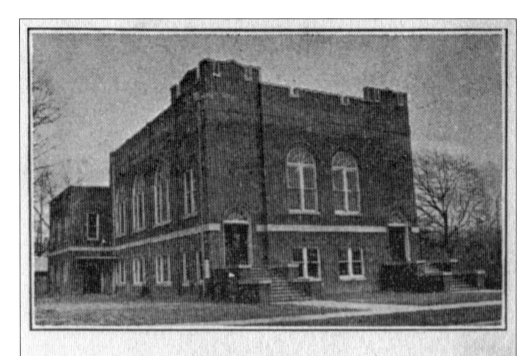

First Christian Church
3rd Street at 3rd Avenue
Amory, Mississippi

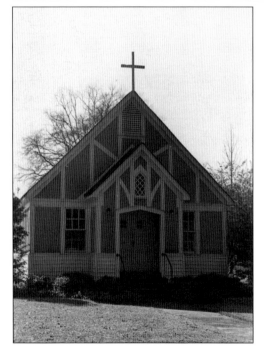

The First Christian Church constructed this building in 1924 at a cost of approximately $15,000. Each window in the building is made of stained glass that was purchased from a company in Memphis for $3,500. The value of the stained glass is now in excess of $150,000. The congregation disbanded in 2008, and the building was purchased by a group of citizens. It is now called The Windows of Amory and is a multipurpose building used for weddings, art shows, receptions, and musical events.

St. Helen's Catholic Church was built in 1942 on the corner of Seventh Avenue South and Eighth Street South. The communicants met in this building until a new church was built in 1998. The original building was sold and became Wildwood Baptist Church, now located on Phillips Schoolhouse Road.

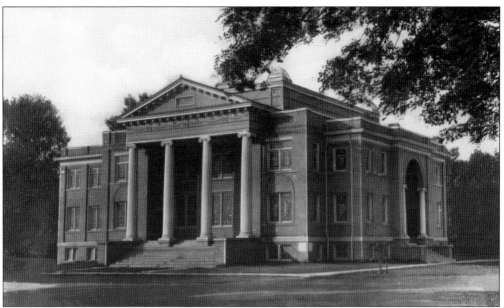

The Baptist Church established a presence in Amory shortly after the town was founded, in the spring of 1888. This photograph shows the First Baptist Church building, located on the corner of First Avenue and Third Street North. Construction on this building started in 1916 and was completed in 1919. Demolition started on the building in 1972 and was completed in 1973. (Courtesy of Mississippi Department of Archives and History.)

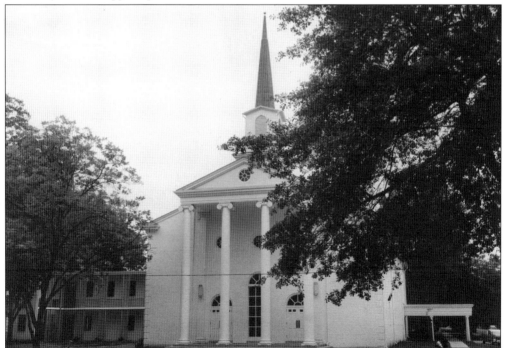

This is the present-day First Baptist Church sanctuary, which stands on the corner of Fourth Street North and First Avenue. Built on a lot purchased from the E.W. Flinn family, the sanctuary was completed in 1961.

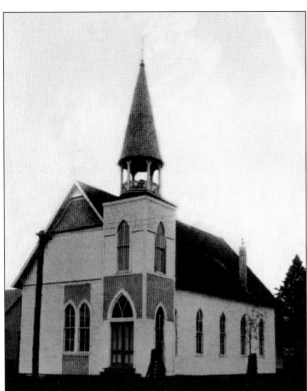

The first Methodist church in Amory was organized in 1888 and met in the structure shown here, on the corner of Second Avenue South and Third Street South. This church stood until a new church was built in 1914. That building was destroyed by fire on January 11, 1926.

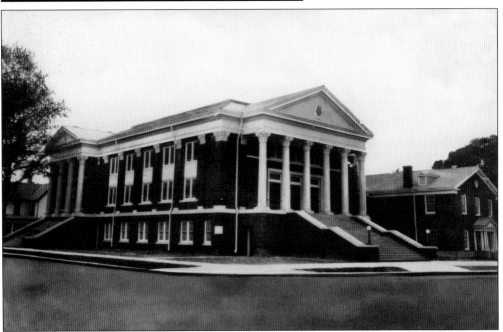

After fire destroyed the First United Methodist Church in 1926, this structure was built on the same location. A fire in February 1936 almost completely destroyed this structure. The determined congregation rebuilt this building, which is still in use today. (Courtesy of Mississippi Department of Archives and History.)

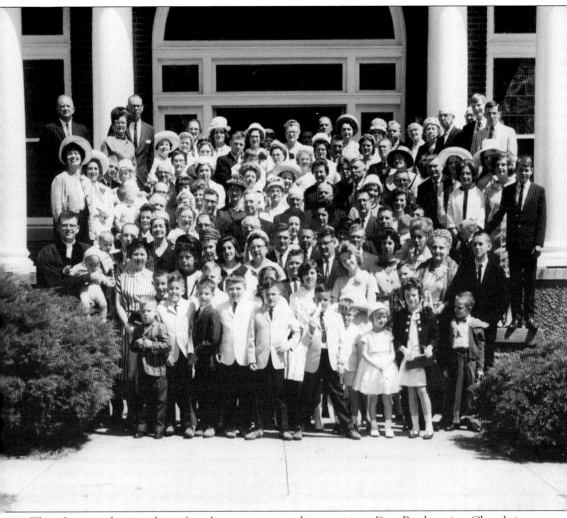

This photograph was taken after the morning worship service at First Presbyterian Church in Amory on Easter, 1963. Included are members of the Jones, Caldwell, Streety, Rainey, Raper, Clements, Dyson, Miller, Alexander, Millender, Beckham, and Knox families, to name a few.

The Presbyterian church was founded in Amory in 1891. Because the congregation was small and did not have the financial resources to do so, a church building was not constructed until the fall of 1929. The church is located on Fourth Street South, on the site of the first school building in Amory.

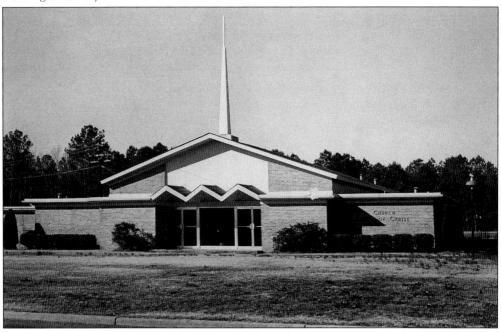

This photograph shows the Amory Church of Christ, located on North Boulevard Drive. This building was constructed in 1962 and still serves the church today. A major renovation and expansion was completed in the fall of 2010.

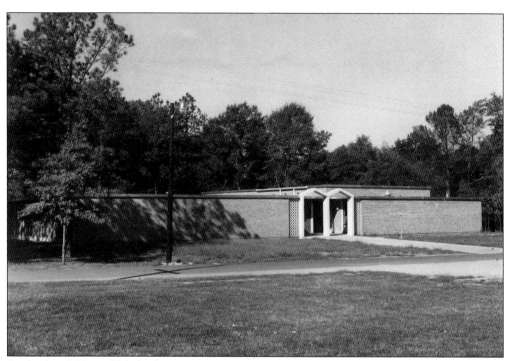

St. Andrew's United Methodist Church was formed in 1958 to increase the Methodist presence in Amory. Dr. Wendell Stockton and several members of First United Methodist Church were instrumental in the formation of the new congregation. The church met in a tent until a sanctuary could be built. The building, shown here, was completed in 1961. A new sanctuary was completed in 1981.

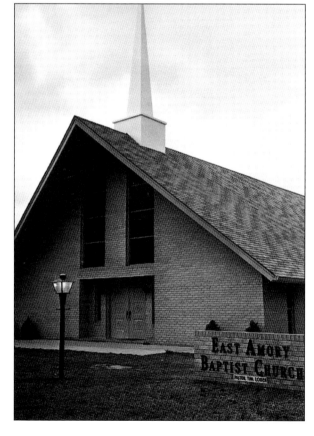

East Amory Baptist Church was opened in 1968 after a congregation moved from Bigbee to Amory. The church is located on Hatley Road in Amory and serves a thriving congregation.

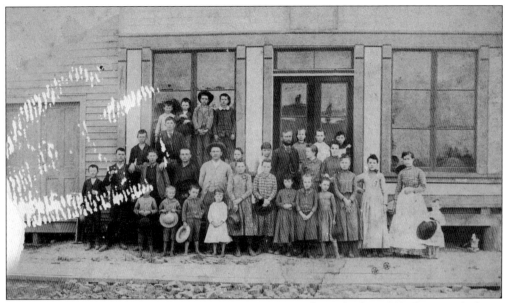

A school was started almost immediately after Amory was formed. This 1889 photograph shows the students at the first school. The building was located on the corner of what is now Main Street North and Fifth Avenue North.

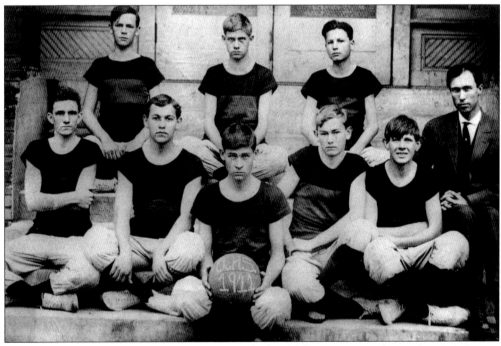

Sports have always played an important part of school life in Amory. This is the 1911 Amory High School basketball team. From left to right are (first row) Garrett Burdine, Tranny Gaddie, Carl Stuckey, Jim Sargent, Ellis Love, and Coach ? Curtis; (second row) Hurschel Parham, Fred Stuckey, and Carrie Lea.

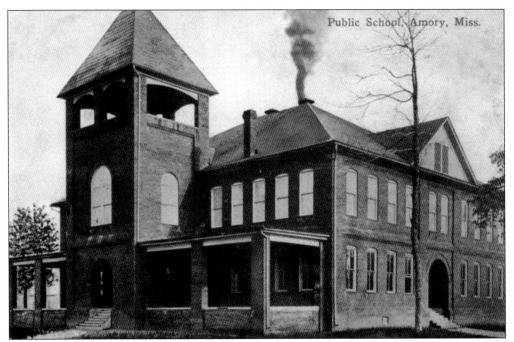

This postcard shows the first public school building in Amory. The school was built on Fourth Street South, on the lot where the First Presbyterian Church is presently located. The building was destroyed by fire in 1914.

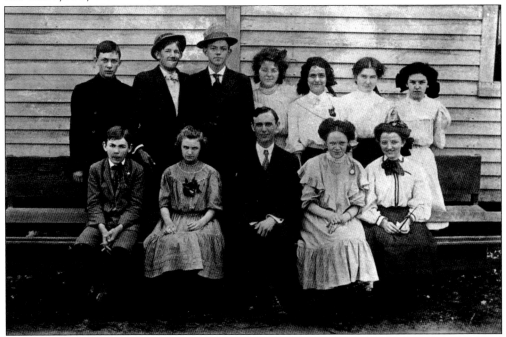

In 1908, students in the Amory school only attended through the eighth grade. This class photograph shows, from left to right, (first row) Edison Allen, Mae Richardson, ? France, Lila Bell Love, and Myrtle Roberts; (second row) Norton Mayfield, Alfred A. Allen, unidentified, Mary Lou Tschudi, Annie Webb, Lizzie Dalrymple, and Grace Smith.

Amory Grammar School was completed in 1924. The school was located on an entire block on Fifth Avenue North, between Seventh Street North and Eighth Street North. The building was unique in that classrooms were built around the auditorium, which was equipped with movable chairs so that it could be used for other purposes. It was the first school building in the state of Mississippi—and, reportedly, the first in the South—to employ safe fire escapes that could also be used as playground slides. The school was closed after the 1975–1976 school year and was torn down in 1977.

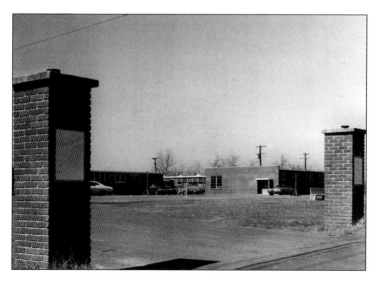

Monroe County Training School was built in 1935 and eventually became West Amory High School. After the public school system in Amory was integrated in the late 1960s, renovations were made and the building became home to West Amory Elementary School. The school is currently used for kindergarten through second grade.

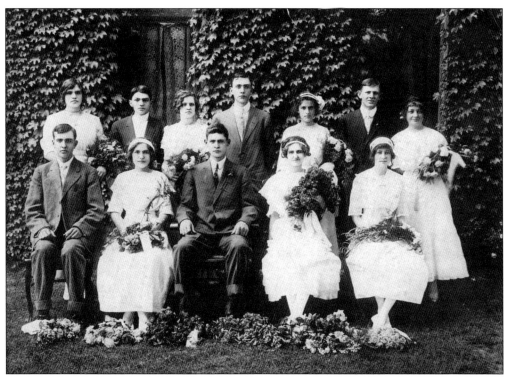

This is a photograph of the Amory High School graduating class of 1913, the first class to complete a curriculum through 12th grade. From left to right are (first row) Horace Baker, Eva Fears, Carl Stuckey, Eva Robinson, and Irma Flinn; (second row) Louise Burkitt, Earl Tubb, Louise Hudson, Cayce Wax, Nellie York, Ellis Love, and Bessie Mayfield.

Etta Dozier Beauchamp began teaching in the Amory school system in the fall of 1918, teaching Latin, French, and Spanish. In 1922, she became principal of Amory High School, a position she held until July 1957, when she became assistant superintendent of the school district. Beauchamp retired in July 1958 after 40 years of service. In October 1958, the Amory School Board decided to name the auditorium at the newly completed Amory High School the Etta Dozier Beauchamp Auditorium in honor of her dedication to Amory schools.

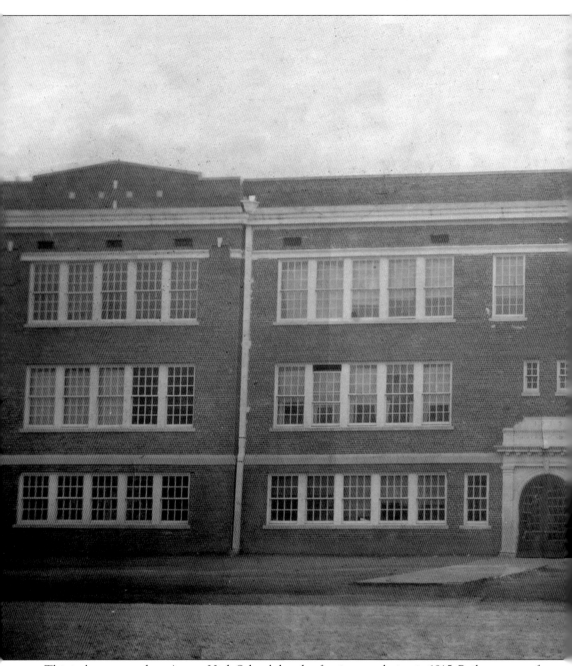

This is the new, modern Amory High School shortly after its completion in 1915. Built at a cost of $35,000, it was reported to be the first school building in Mississippi to have a full basement that was entirely aboveground, and the first to have uniform lighting in all classrooms. The school was

equipped with the most modern furniture of the time, and the color scheme of the building was copied after the city school system buildings in Cleveland, Ohio. The building was torn down in 1961 to make way for the ultra-modern Amory Middle School, which was built on this site.

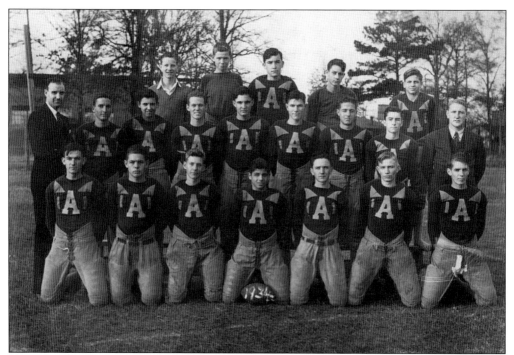

This photograph shows the 1934 Amory High School Panther football team. The team members are, from left to right, (first row) R.J. Jones, Neal Williams, John Owens, Joe Bridges, Frank Page, Otis Pearce, and L.N. Williams; (second row) F.A. McLendon (principal), Busey Lamon, Jake Powell, Hudson Anthony, ? Glenn, Harold Jones, Dick Streety, Edgar Ware, and John J. Reed (coach); (third row) Grant Gregory, James Fitzpatrick, Coy Glenn, ? Summerford, and Wilbur Bridges.

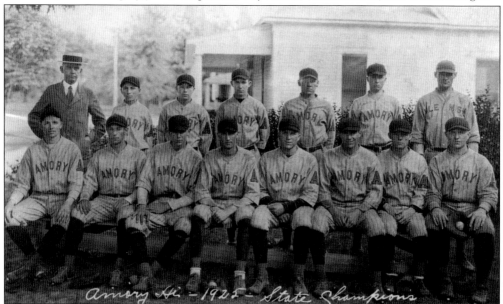

In 1925, the Amory High baseball team captured the state championship. This was the first team from Amory High School to win a state championship. The members of the squad are not identified.

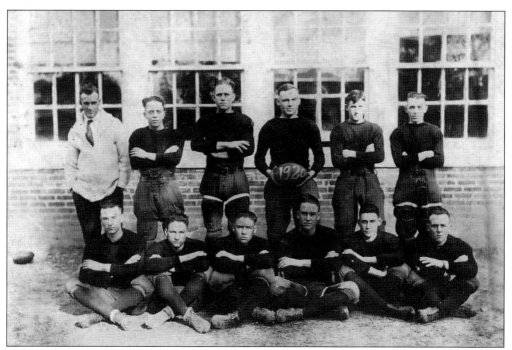

Amory High School has been fielding athletic teams since 1909, and the first football team took the field in 1913. Shown here are the members of the 1920 football team with their coach. The team members are not identified.

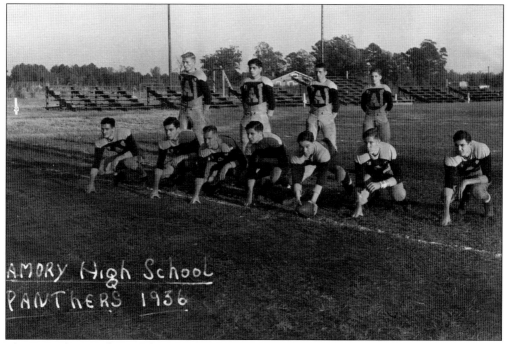

These are the members of the 1936 Amory High football team. Pictured are, from left to right, (first row) R.J. Jones, Burdine Gregory, Wilbur Bridges, Jack Bentley, Lewis Sellers, and Jake Powell; (second row) Otis Pearce, Joe Bridges, unidentified, and Robert Baird.

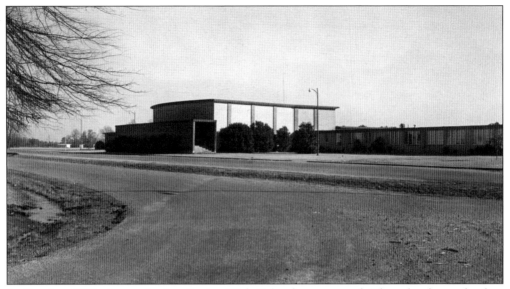

In October 1958, Amory Junior–Senior High School was opened. The school was the first combination junior high school and high school in Mississippi. The building cost $705,000 to construct and is located on Sam Haskell Circle off of North Boulevard Drive.

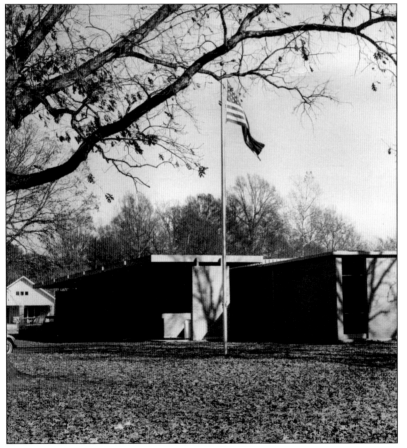

Opened in the fall of 1963, Amory Middle School was the first such school in the mid-South region. Housing grades five through eight, the school was noted for its innovations and modern design. This was the first totally air-conditioned school building in Amory.

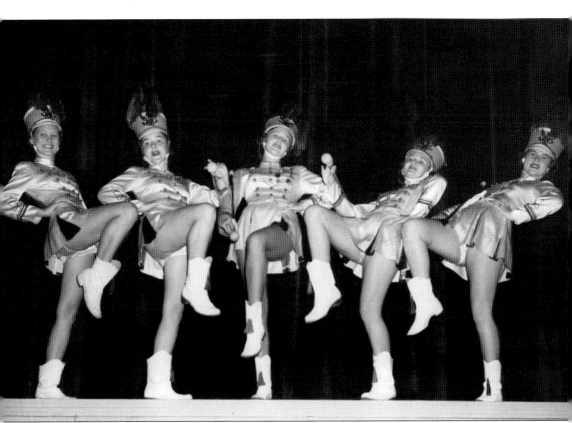

Leading the 1951–1952 Amory Panther band were these majorettes. They are, from left to right, Peggy Barnett, Jo Ann Liddell, Billie Jean McFadden, Melinda Coyle, and Mary Ruth Noland.

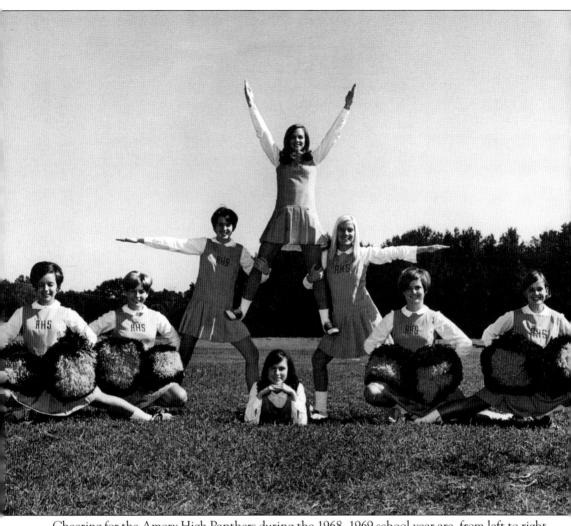

Cheering for the Amory High Panthers during the 1968–1969 school year are, from left to right, Karen Justice, Martha Smith, Patti Pierce, Charlotte Parham, Diane Hathcock, Dale Hester, Karen Tabbert, and Belinda Conn.

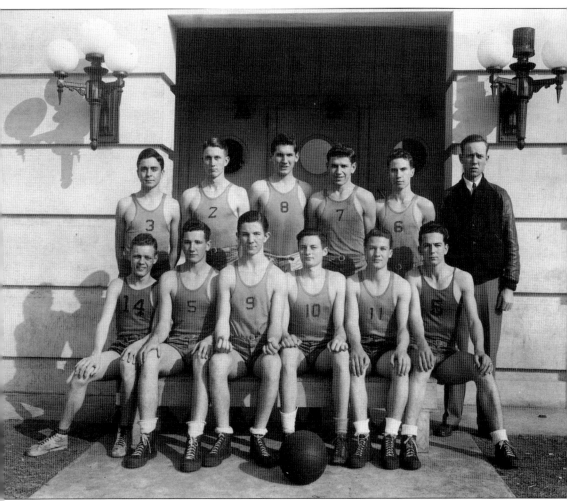

This photograph of the 1945 Amory High School basketball team was taken on the steps of the National Guard Armory, where the team played home games. The team included, from left to right, (first row) Richard Huffman, Bill Jones, Glenn Scott, John Earl Whitaker, Fred Stanford, and Charles Kennedy; (second row) Bert Hill, Pete Hodo, Joel Foshee, Don Perkins, Jack Pennel, and Fay Reid (coach).

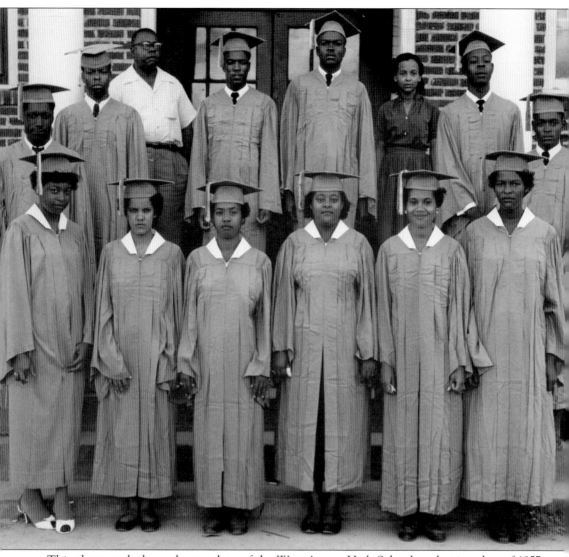

This photograph shows the members of the West Amory High School graduating class of 1957. The front row includes, among others, Evalena Hannah, Mary Frances Shaw, Mary Sue James, and Odessa Lackey; in the second row, from left to right, are Willie G. Ford, James Martin, professor James Pope, Charles Whitfield, Rachel B. Dunn, George Johnson, and Boyd McKinney.

Four
BUSINESS AND INDUSTRY

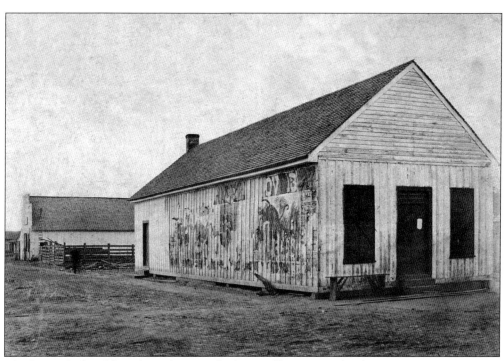

The Frisco Railroad has always been at the heart of business and industry in Amory. However, since the founding of the city, there have been many other industries and businesses that have also called Amory home. Several businesses were moved to Amory from Cotton Gin Port in 1887 and made the town a center for commerce in the area almost instantly. The garment industry also played a major part in the economic development in this area, with four major plants in operation at one time. Health care has also been important to Amory's growth. Gilmore Sanitarium, which became Gilmore Memorial Hospital and is now Gilmore Memorial Regional Medical Center, has provided quality health care for this area. Today, Amory is the home to a variety of businesses and industries, as well as retail establishments. This photograph shows the first store in Amory, at the intersection of what is now First Avenue and Main Street.

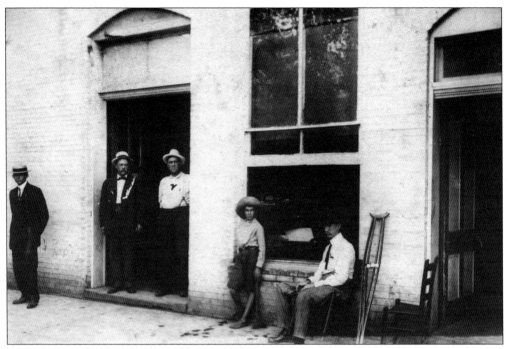

This photograph was taken around 1910 in front of Amory City Hall on Main Street. The man at left is James A. Mayfield, who was mayor at the time, and the man to the right of him is W.B. Dillingham, the city clerk.

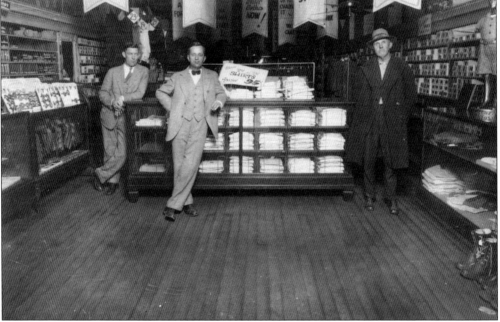

One of Amory's earliest merchants was James A. Mayfield, who operated a store at Cotton Gin Port and moved his business to town when the railroad came through. This is the interior of J.A. Mayfield Dry Goods, which was on Main Street North and First Avenue. From left to right are Dan Mayfield, James A. Mayfield, and an unidentified man.

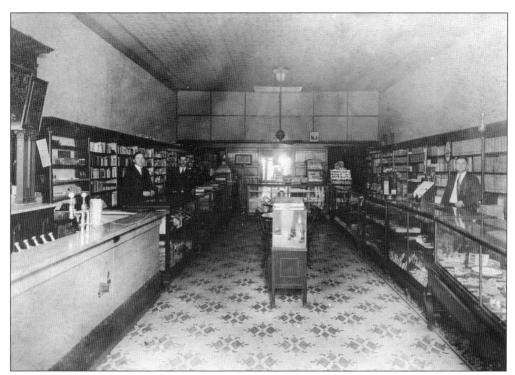

This photograph of Peoples Drug Co. was taken in 1921. The business was started in 1893 and was in operation until 2010. From left to right are J.S. Abney, H.O. Crump, and P.B. Williams.

Will Cheek and Kirb Kirkpatrick founded this blacksmith shop in 1912. In 1933, H.C. "Popeye" Parker moved to Amory to buy the business from G.H. Kirkpatrick, a cousin of one of the original owners. Parker operated the blacksmith shop, one of the last in Mississippi, until his retirement in August 1977.

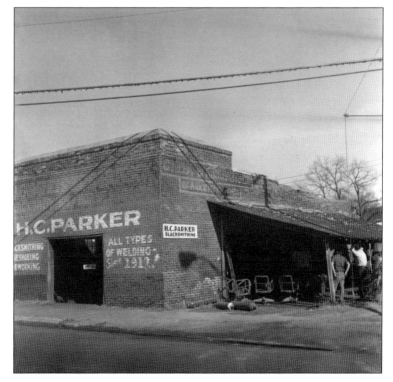

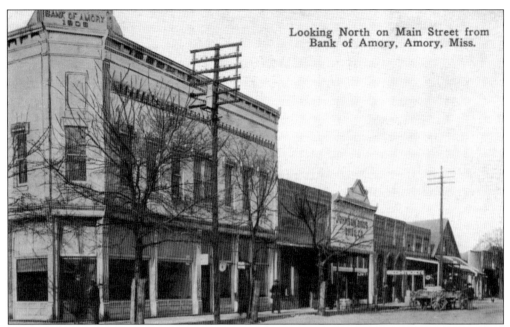

This postcard from the early 1900s shows a growing and developing Main Street. The Bank of Amory opened for business in 1906 and now operates as Renasant Bank. This view is looking north from present-day Second Avenue North.

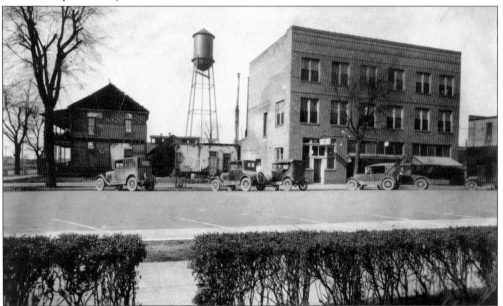

Brothers Naum and Chris James bought the Amory Hotel-Café in the 1920s. Seen here in the late 1920s, the building to the left housed the café, while the brick structure was the hotel. The James brothers eventually constructed a new building to replace the wooden structure that stood on the corner of Front Street and First Avenue. Since the café operated 24 hours a day, seven days a week, when the James family closed the doors to the restaurant in 1972, the key to lock the front door could not be located. The Amory Café-Hotel was torn down during the urban renewal era in Amory.

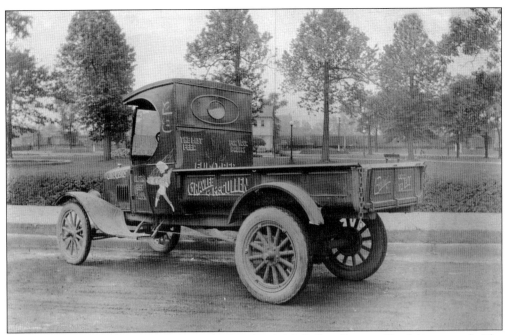

This photograph from the 1920s shows the Gravlee & McCullen Grocery Co. delivery truck. The McCullen family continued to operate a grocery business on Main Street until October 1988. Delivery was available until the last day of business.

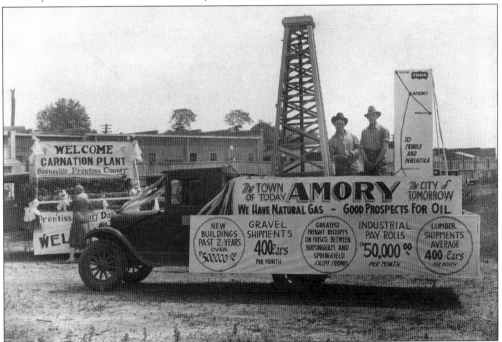

When the Carnation Milk Plant was opened in Tupelo on May 12, 1927, it was a cause to celebrate. This is the Amory float that was in the parade celebrating the opening of the new plant. Note that the float proudly touts Amory's railroad and natural gas industries, both of which spurred growth in the area for years.

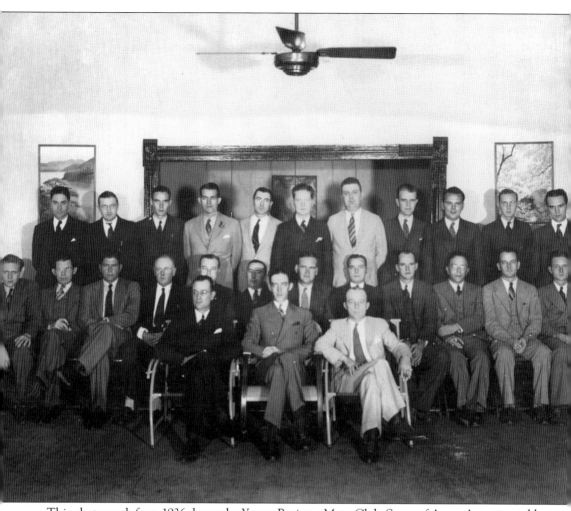

This photograph from 1936 shows the Young Business Mens Club. Some of Amory's most notable businessmen are pictured here. From left to right are (first row) Linwood Dickinson, Erbie Lee Puckett, and Aleck Cutcliff; (second row) Foy Pullen, Ollie Owens, Grave Armstrong, Sam West, Brannock May, Norton Camp, Robert Earl Bentley, Dick Jones, Buddy Crump, Oliver Willis, Will Hunter Ryan, and Bennie Hodo; (third row) Jack Horner, Jay Dawson, Luke Inzer, Wayne Floyd, Dr. P.J. Smith, S.J. Cox, Aubrey Brasfield, E.J. Gilmore, Charles Pickle, William Coyle, and Guy R. Pickle.

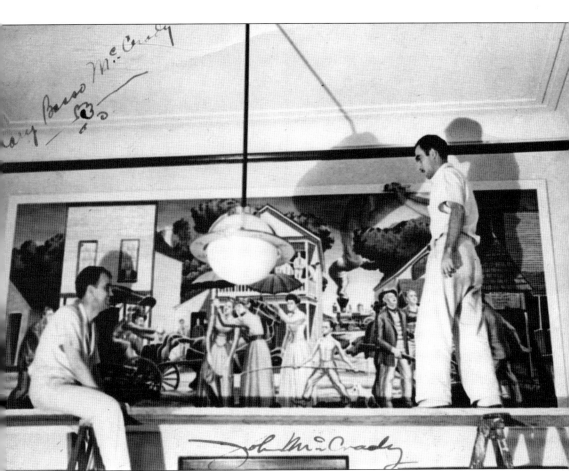

New Orleans artist John McCrady puts the finishing touches on a mural he painted in the post office in Amory as his good friend E.J. Gilmore looks on. The mural depicts Amory in 1888. McCrady, who did several of these post office murals around the South, liked to paint himself into his paintings. He is not visible in this photograph, but, in the painting, he is standing on the balcony of the building in the middle with his arms outstretched. Gilmore went on to commission McCrady to paint portraits of his parents, E.D. and Virginia Gilmore. These portraits now hang in the Gilmore Foundation Conference Center.

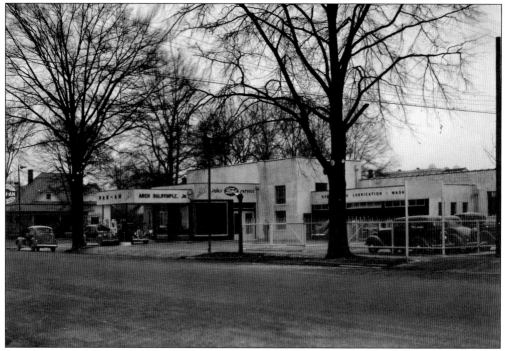

This photograph from the 1930s shows the Arch Dalrymple Jr. Ford dealership. A Pan-Am gasoline and service station was also located at this facility. The building was located on the corner of Third Street North and Second Avenue North.

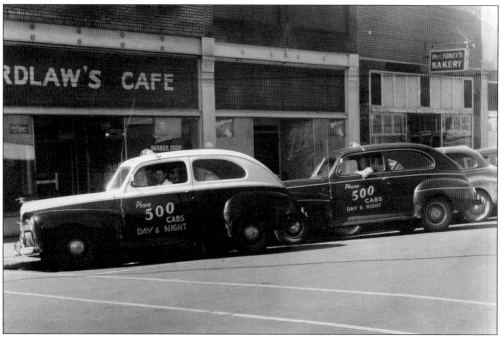

In the 1940s, not everyone in Amory had an automobile. Cab service was very helpful to those who needed transportation around town. These 500 Cab company taxis are ready for their next fare as they wait on the corner of First Avenue and Main Street North.

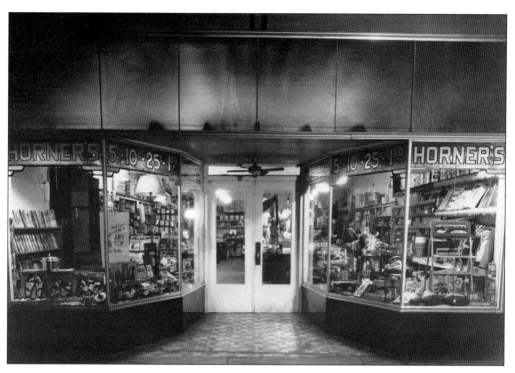

Horner's Variety Store on Main Street North was a popular place to shop in the late 1940s. The photograph above shows a wide variety of goods for sale. Horner's was closed in the early 1950s. Next door to Horner's Variety Store was Horner's Grocery (below), a self-service grocery store.

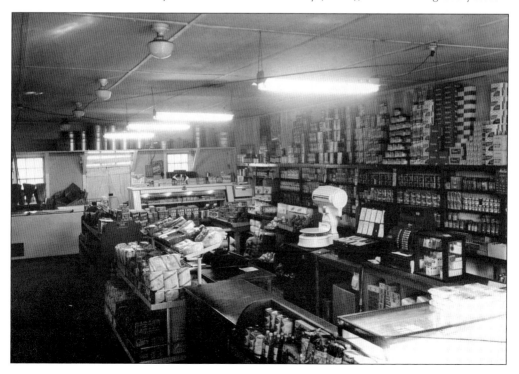

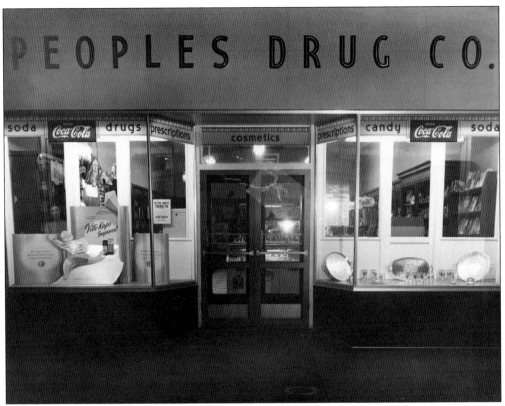

Peoples Drug Co. was opened in 1893 on Main Street. The business burned in 1895 but was rebuilt at the same location. J.S. Abney and his partner sold the drugstore to Evelyn Gregory in 1944. The business was eventually closed in December 2010. This photograph from the 1950s reflects the wide range of products available at Peoples. Today, the space is part of a restaurant next door.

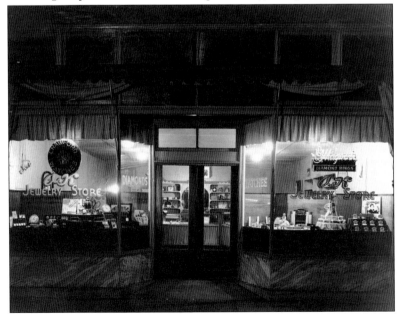

Located in a building that was constructed in 1905, OK Jewelry Store was opened at 119 North Main Street in 1935 by William Ollie Knight. OK Jewelry was in operation until it was sold to Eugene Wright in 1968. Today, the building is a restaurant.

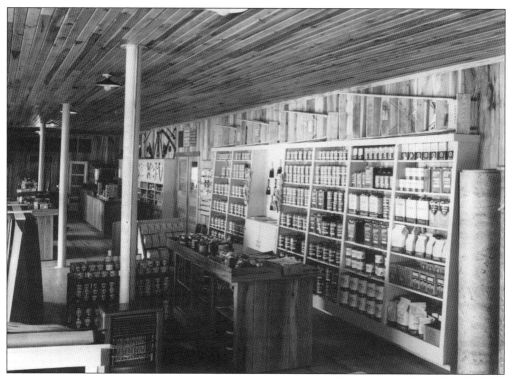

Hale Lumber Company, owned and operated by Evan Hale, was located on Highway 25 South in Amory. The lumber company was a full-service store that sold most items a carpenter would need. This photograph of the inside of the store in the 1950s shows the wide variety of items for sale.

This photograph of Amory City Hall was taken around 1957. The building was constructed in 1910 and was the power plant for the city until 1921, when it was converted to city hall. The original building was only one story; the second story was added in 1935 with Works Progress Administration labor. The building was torn down in 1969 when city hall was moved to the former Frisco division headquarters building at Frisco Park. The town library was inside city hall until 1965.

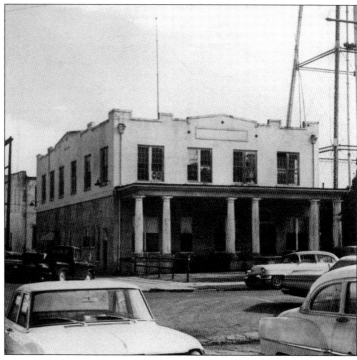

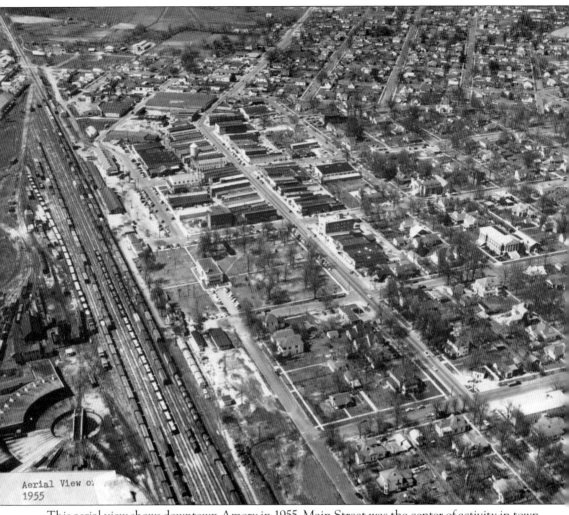

This aerial view shows downtown Amory in 1955. Main Street was the center of activity in town, and, as the photograph shows, the Frisco Railroad was a major economic force.

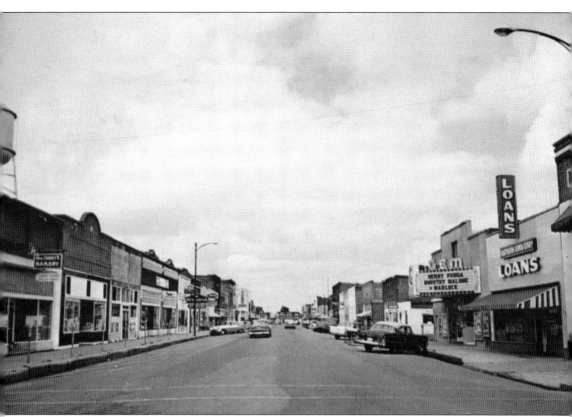

This 1959 postcard of Main Street shows a business district that had stores for just about anything the town needed. On the left is the entrance to Toney's Bakery, and on the right is the Gem Theatre, one of the three movie theaters downtown.

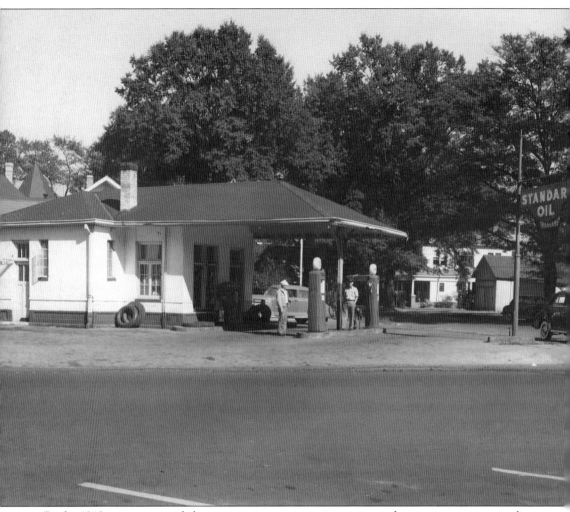

By the 1940s, as more people began to own cars, it was important to have easy access to gasoline. This Standard Oil station stood on the corner of Second Avenue South and South Main Street. The location later became a Chevron station that was owned and operated by O.T. McFarling for many years.

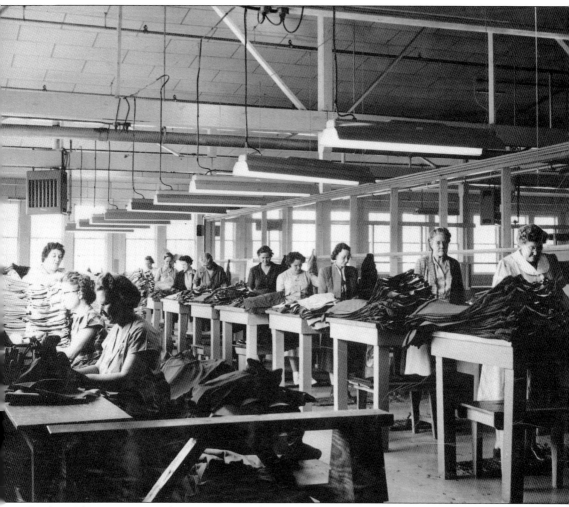

In the 1950s, garment production was in full swing in Amory. This is a photograph of some of the inspectors at Amory Garment Company checking recently completed pants. The company was started in 1935 by the Longenecker family and was sold to the Block Corporation in 2000. In 2006, it was moved to Tupelo.

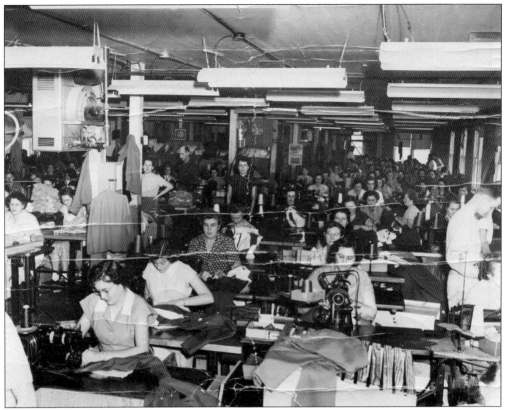

Wilson Manufacturing was another of the garment-related industries in Amory. This photograph from the 1950s shows the sewing floor at Wilson in full production. The Wilson Manufacturing building was at the corner of Third Avenue North and North Main Street downtown.

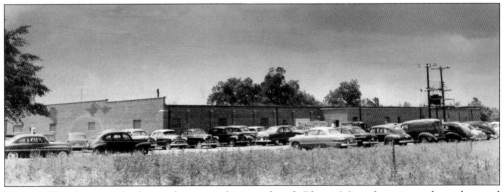

This 1950s photograph shows the recently completed Glenn Manufacturing plant, located on Highway 278 East. The garment industry played a very important role in the growth and development of the area.

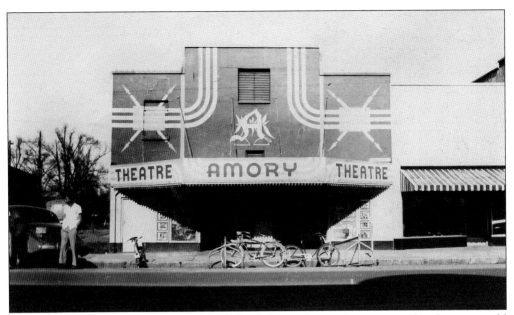

The Amory Theatre was located at 106 North Main Street downtown. The theater would eventually become the Gem Theater and would remain in business until the mid-1970s. It is pictured here in March 1953.

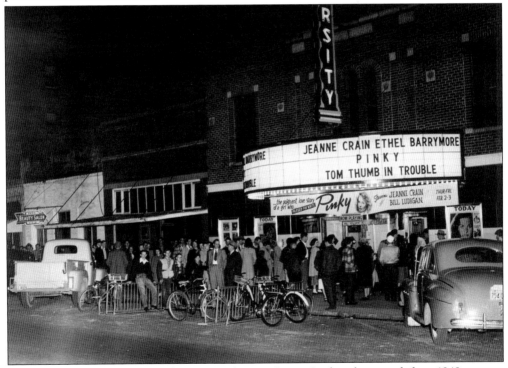

The Varsity Theatre was located at 115 South Main Street. In this photograph from 1949, patrons are standing in line to buy tickets to the movie *Pinky*. Movies provided much entertainment for the people of Amory, and at one point, there were three theaters downtown. The Varsity closed in the early 1960s.

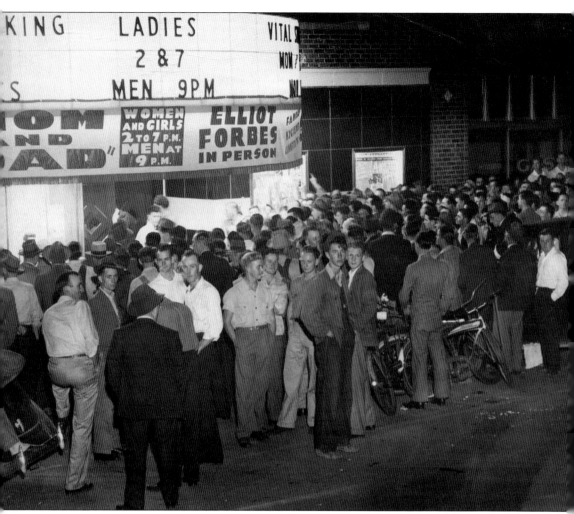

A huge crowd has gathered outside the Varsity Theatre to see the controversial 1945 movie *Mom and Dad*. Men and women were not allowed to see the film together, so there were separate viewing times for each. The movie became one of the highest-grossing films of the 1940s.

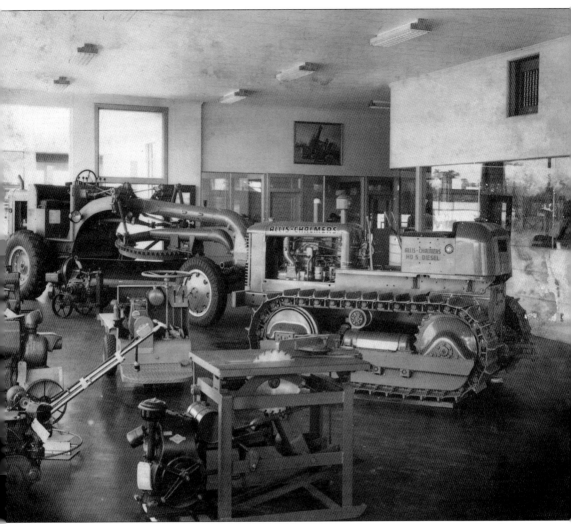

Dalrymple Equipment Company sold heavy machinery needed in the construction of roads and highways across the South. J.R. Scribner eventually bought the company, and it soon became one of the largest dealers of Allis-Chalmers equipment in the nation. Scribner Equipment Company, located on Highway 278, was closed in the early 1990s.

Pictured here in the 1950s is the exterior of Dalrymple Equipment Company and some of the equipment that was sold by the company.

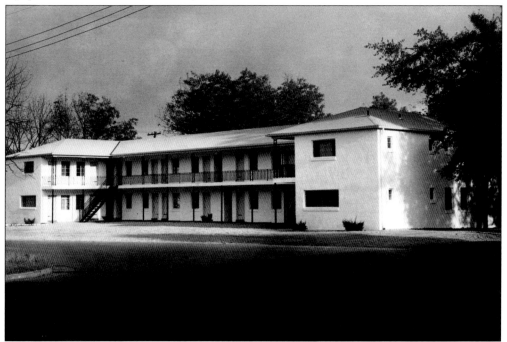
As more and more Americans began to travel for leisure, Amory realized the need for a place to accommodate visitors. The Lounge Motel was opened on South Main Street in the late 1950s. It is still in operation today as the Tenn-Tom Inn.

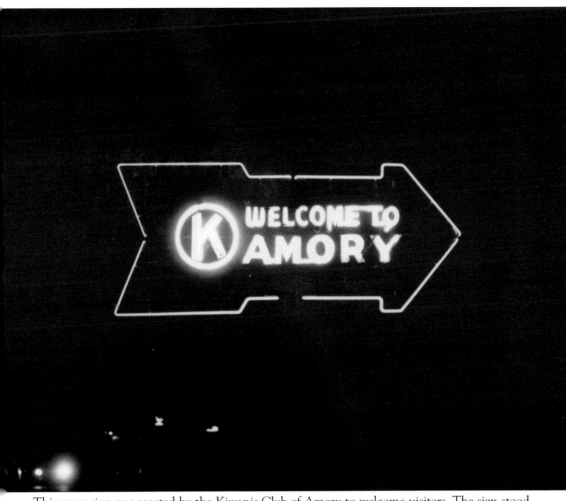
This neon sign was erected by the Kiwanis Club of Amory to welcome visitors. The sign stood at the corner of Highway 278 West and South Main Street.

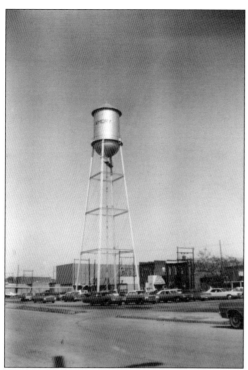

This is Amory's iconic water tower, which stood watch over downtown from the 1910s until it was taken down in late 1969 as part of urban renewal. The water tower stood beside the old city hall and the fire department on Front Street.

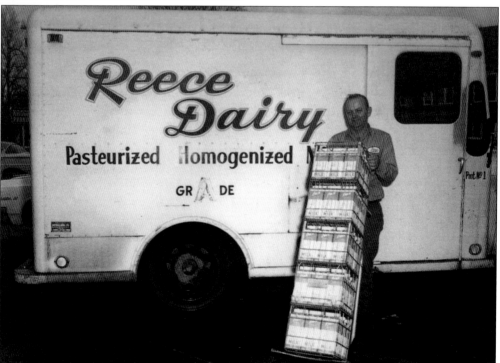

Reece Dairy products were a staple in Amory homes for many years. In the 1960s, longtime employee Harvey Justice delivers milk to the Kroger. At one time, Amory was home to three dairies: Reece, Kirkpatrick Dairy, and Gregory Dairy. Reece Dairy closed in the mid-1980s.

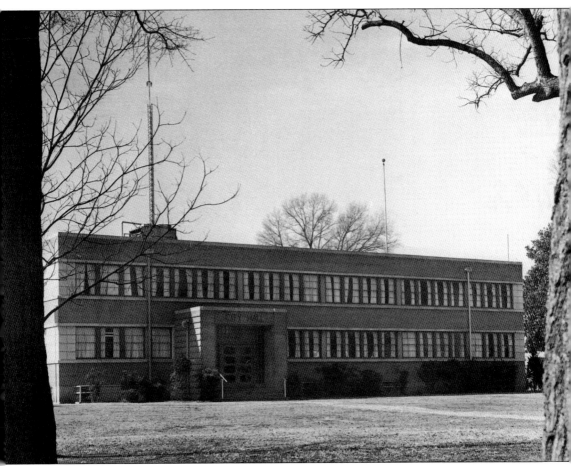

This photograph from 1970 shows city hall shortly after a complete renovation. The building was purchased from the Frisco Railroad after the company moved its Southern Division headquarters to Memphis. Today, the offices of the mayor, the city clerk, and the city planner, as well as the city board room and municipal court, are located there.

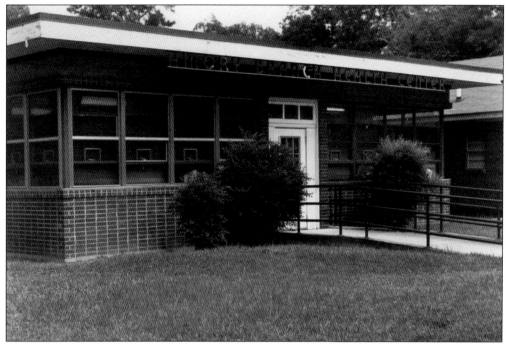

The Mississippi Department of Health, Amory Branch, was located in this building on South Main Street. In the 1980s, the office was relocated to a new facility on Highway 25 South. Today, this office is the home of the Amory Housing Authority.

This 1950s photograph shows the corner of First Avenue and South Main Street. The building was originally built as the J.A. Mayfield Dry Goods store. After the Mayfield store closed, the building housed a restaurant on the ground floor and a pool hall upstairs. To the left is the Amory Café, which was open 24 hours a day, seven days a week.

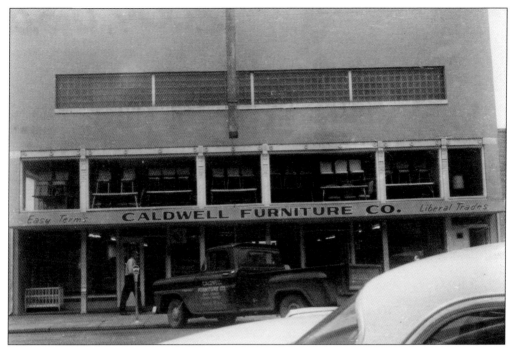

Caldwell Furniture was the first furniture store in Amory. It was located on the corner of North Main Street and Third Avenue North. The business was closed in the early 1970s.

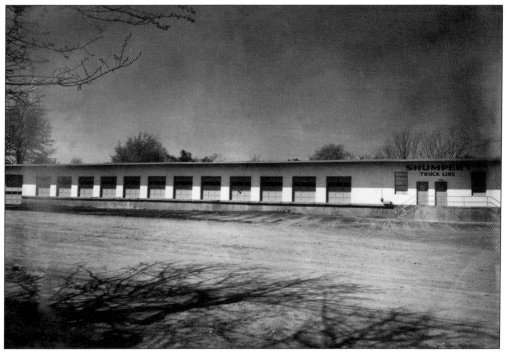

Shumpert Truck Line was a locally owned trucking company located on Highway 278 West. Shown here in the 1950s are the company's new terminal and offices. The company was sold to Merchants Truck Line in the 1970s.

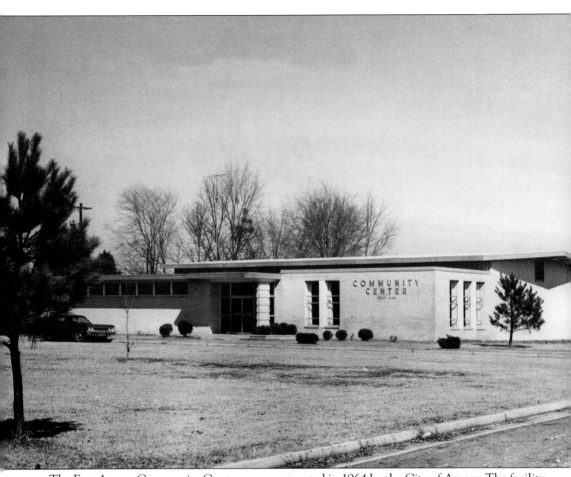
The East Amory Community Center was constructed in 1964 by the City of Amory. The facility is located near Amory High School and has provided the community a place to hold family reunions, dances, meetings, and day camps, and serves as a polling place for elections.

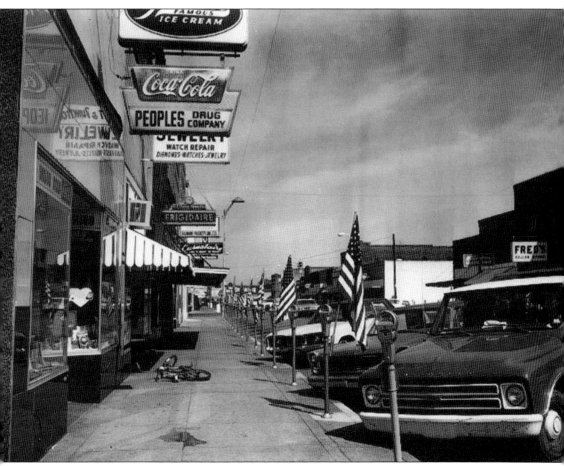

This photograph shows a quiet, peaceful downtown Amory on Labor Day 1968. The business signs and parking meters would soon be taken down, as urban renewal started in the spring of 1969.

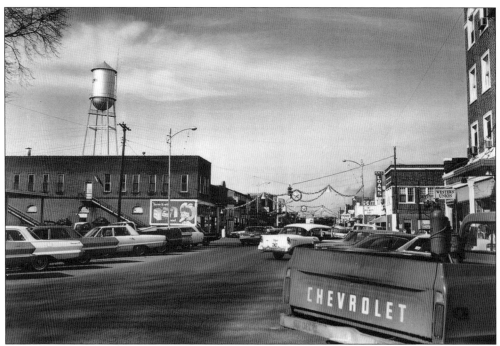

Christmas 1967 was a busy time downtown as Amorians prepared for the coming holiday season. On the right is the Park Hotel, which was built in 1926. This view is looking north on Main Street in front of the *Amory Advertiser* offices.

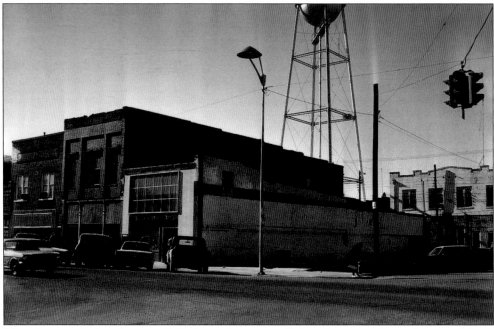

This photograph from January 1968 shows the corner of Main Street and Second Avenue North before urban renewal began. Security Bank of Amory constructed a new building on the vacant space on the corner that was formerly home to McCutcheon Banks furniture store. On the right is the rear of the old Amory City Hall.

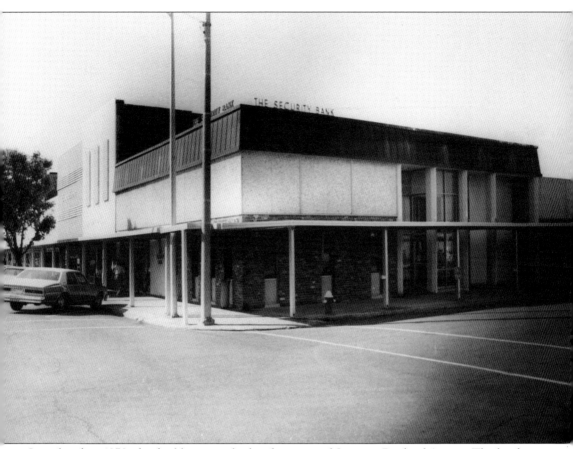
Completed in 1970, this building was the headquarters of Security Bank of Amory. The bank was sold to Community Bank and moved to a new facility on North Main Street. Presently, the City of Amory Utility Department is housed here.

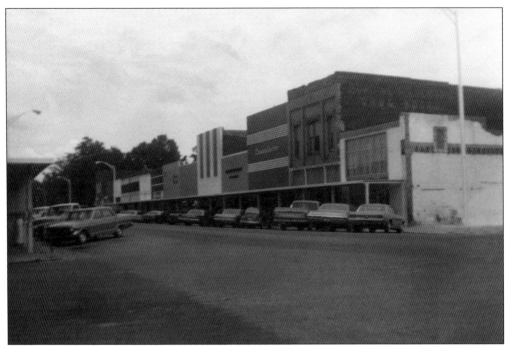

The final stages of urban renewal are evident in this view from the corner of Second Avenue North and Main Street in 1969. These building facades and sidewalk awnings on Main Street were completed in 1970.

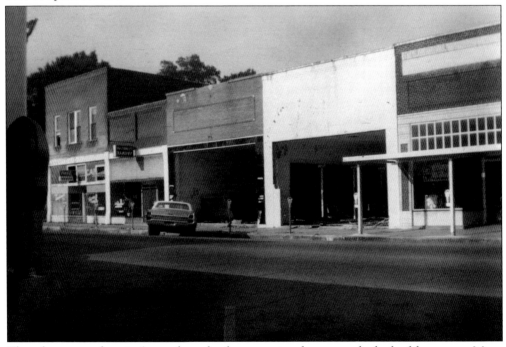

The urban renewal era in Amory brought about massive changes to the look of downtown. Many buildings were completely renovated and their exteriors updated with new facades. These buildings are located on North Main Street.

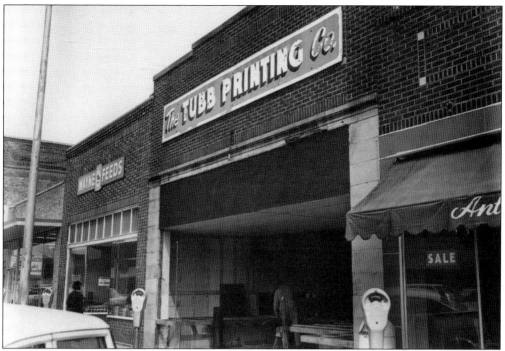

As urban renewal continued, some businesses left Main Street while others moved into the newly renovated spaces. Tubb Printing Company was started in the 1920s and was a fixture in the business district. The company moved off of Main Street in 1970 to a new location on Third Street North, almost directly behind this location. Star Printing Company of Amory purchased Tubb Printing in the mid-1970s.

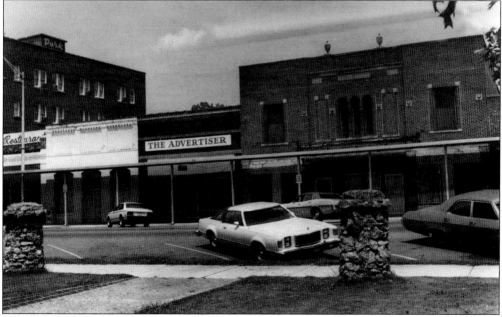

This is the exterior of the former Varsity Theatre in the mid-1970s. The *Amory Advertiser*, now the *Monroe Journal*, eventually purchased the building and moved its offices there.

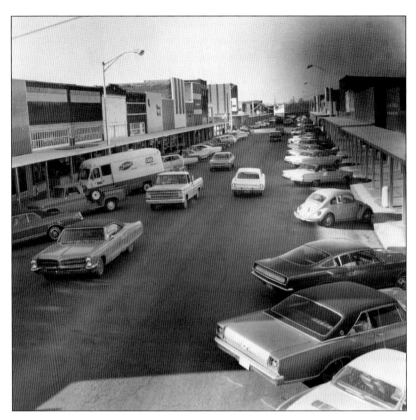

Most of the major work of urban renewal was completed by the time this photograph of North Main Street was taken during the Christmas season in 1970.

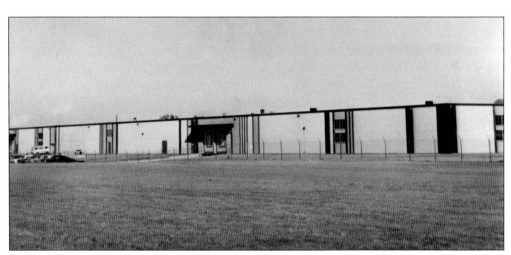

In 1963, True Temper Corporation decided on Amory for its new manufacturing plant. This photograph from 1969 shows the completed plant, located in south Amory. True Temper Corporation is the largest manufacturer of golf club shafts in the world.

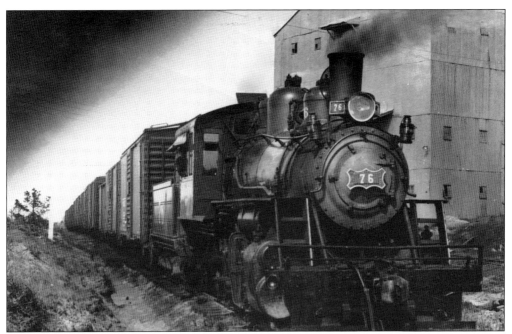

The Mississippian Railroad is a 24-mile, short-line railroad that operates between Amory and Fulton. In 1947, the Mississippian Railroad purchased steam engine No. 76 from the Frisco Railroad. This photograph from the 1950s shows engine 76 bringing a load of freight from Fulton to the Frisco yard in Amory.

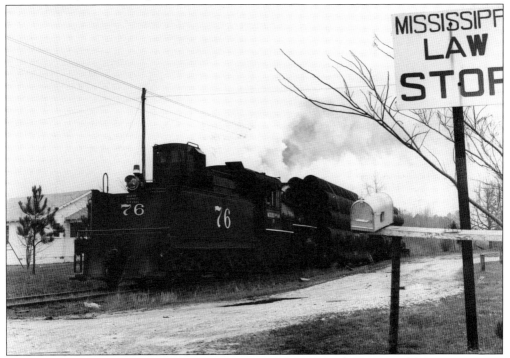

Engine 76 operated on the Mississippian until September 1967, when it was sold to a company in Blairsville, Pennsylvania. The engine was built by Baldwin Locomotive Works in 1920.

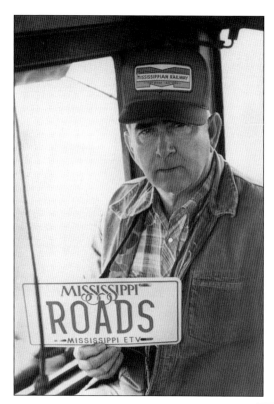

The Carlisle family has been involved in the Mississippian Railroad since the beginning of the line in 1925. Here, James Carlisle poses during a break in filming of an episode of *Mississippi Roads* for Mississippi Public Television. The television series looks at unique places, people, and attractions around Mississippi.

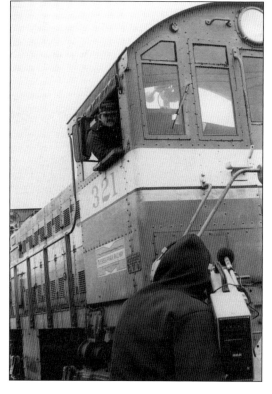

Buddy Carlisle is shown in the cab of engine No. 321 during the filming of *Mississippi Roads* for Mississippi Public Television. Presently, Carlisle is the general manager of the Mississippian. This episode of *Mississippi Roads* aired in the mid-1980s.

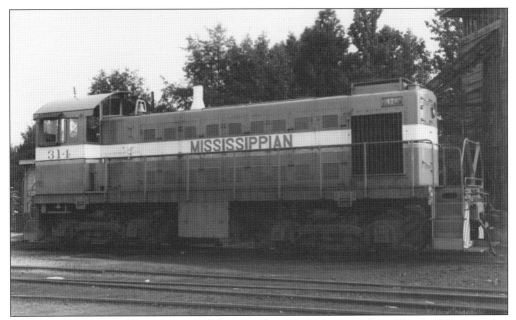

Shown here is Mississippian No. 314. This was the first engine purchased by the Mississippian after the discontinuation of the steam engines in 1967. This engine was purchased from the Erie Lackawana Railroad. (Courtesy of P&K Enterprises.)

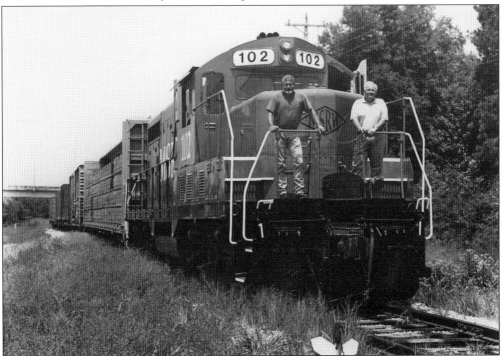

Charles Holloway (left) and Buddy Carlisle pause while bringing Mississippian No. 102 southbound from Fulton on August 4, 2004. Now owned by the Itawamba County Development Council, the railroad continues to provide service between Amory and Fulton three times weekly. (Courtesy of Louis R. Saillard.)

The Magnolia State Railway was formed in 1980 with the purpose of providing historical and educational rail excursions between Amory and Smithville. The railroad also carried passengers during the annual Amory Railroad Festival. The train continued to operate until the late 1980s, when rising operational costs forced the discontinuation of service. Here, Mississippian (MSR) No. 77 is arriving at the Concord Street station in Amory.

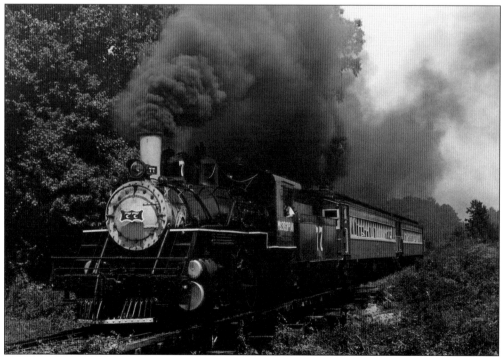

Shown in full steam is MSR 77, just outside of Amory on a trip to Fulton. In the 1980s, the Magnolia State Railway provided excursions on weekends between the end of May and Labor Day.

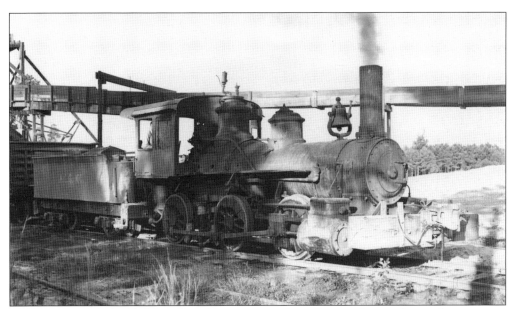

The Frisco Railroad and the Mississippian were not the only ones that used steam locomotives. Shown in this photograph from October 4, 1940, is Amory Concrete Gravel Company's engine No. 2. The Porter-built engine was purchased from the Escambia Railroad Company of Florida.

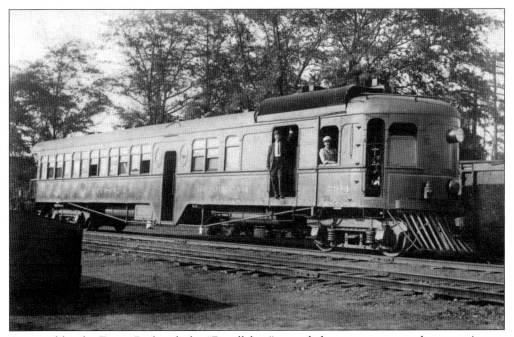

Operated by the Frisco Railroad, the "Doodlebug" provided passenger service between Amory and Aberdeen. The unique-looking train is shown waiting for passengers in Aberdeen in the 1920s. In the doorway is J.C. Glozier, the conductor.

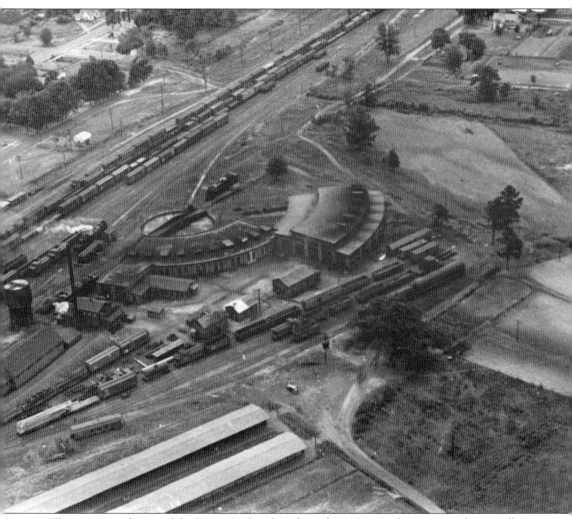
This is an aerial view of the Frisco Railroad yards in the 1920s. In the center is the roundhouse, where repairs and maintenance were performed on locomotives. The Amory yard and roundhouse were vital to the operations of the Southern Division of the Frisco.

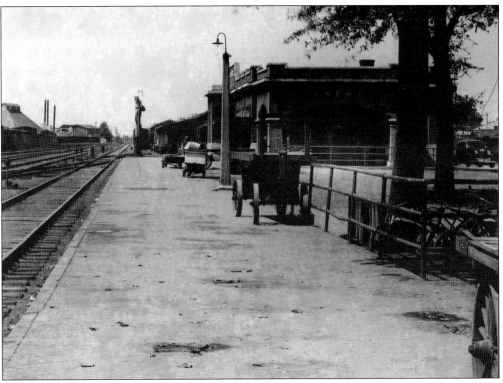

This is a 1940s trackside view of the Frisco depot. At the height of passenger train service, 12 passenger trains a day came through Amory. The depot was demolished in 1969 as part of urban renewal.

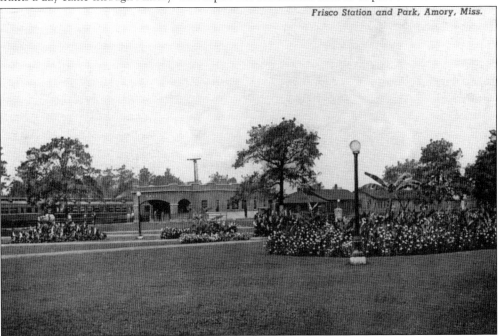

This postcard from the 1920s shows a well-manicured Frisco Park and train station. The Frisco set aside the area for the park when the town was founded in 1887.

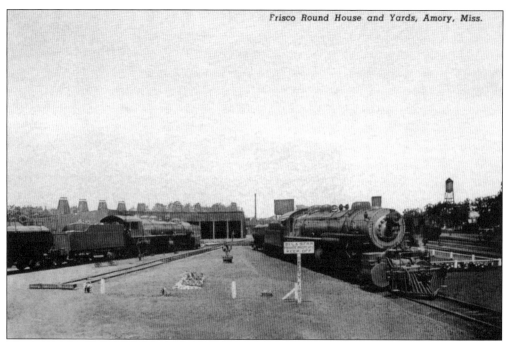

The hub of the rail yard in Amory was the roundhouse. This 1923 postcard shows locomotives both leaving and arriving at the facility. The sign in the foreground reminds everyone "safety first."

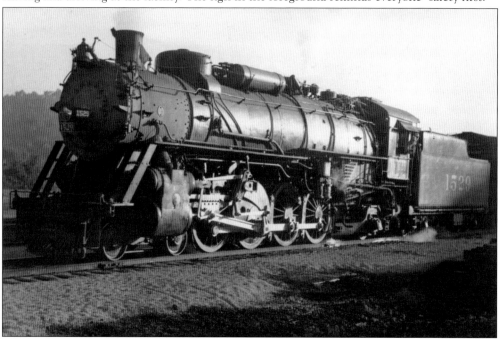

Frisco engine No. 1529 is shown leaving Kansas City, Missouri, in May 1948. Engine 1529 is the locomotive that brought Pres. Franklin D. Roosevelt and his wife, Eleanor, to Amory in 1934. In 1953, as a gift to Amory and to honor the completion of the Southern Division headquarters, Frisco placed engine 1529 on permanent display in Frisco Park. The engine, one of only six like it left in the United States, was renovated in 2011.

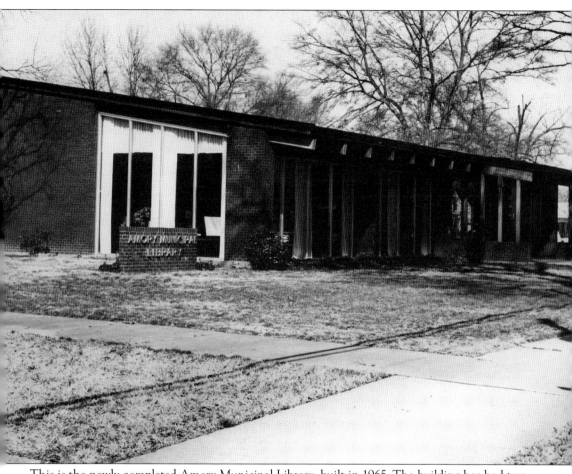
This is the newly completed Amory Municipal Library, built in 1965. The building has had two expansions, one in 1985 and one in 1995. The library is part of the Tombigbee Regional Library System. Until this building was completed, the library had been located on the bottom floor of city hall on Front Street.

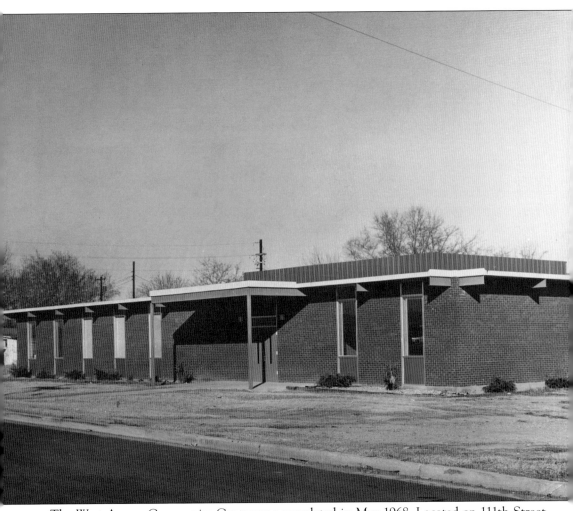
The West Amory Community Center was completed in May 1968. Located on 111th Street across from West Amory Elementary School, the center is a vital part of the community that hosts many community events.

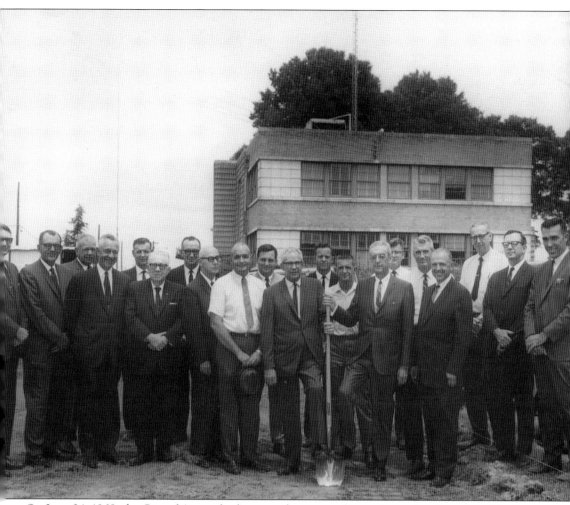

On June 24, 1968, the City of Amory broke ground on a new fire station on land purchased from the Frisco Railroad. Shown at the ceremonial ground-breaking are, from left to right, (first row) J.E. Gilliland, E.C. Bourland, Arthur Mariocourt, Earl Frye, William Ross, Erbie Lee Puckett, and E.G. Krewling; (second row) Nathan Devers, Robert Akins, E.E. Kerr, Jim Hall, Roy Ausbon, Jim Brown, Hester Pickle, Henry Grady Wright, Larry Buffington, Bill Cooke, T.D. Harden, J.O. Prude III, and Elvin Farrar.

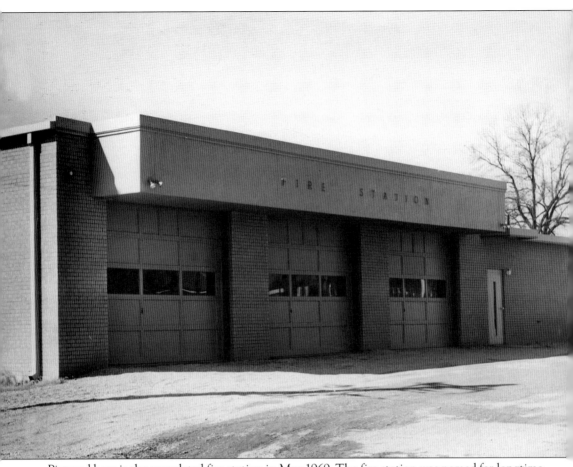
Pictured here is the completed fire station in May 1969. The fire station was named for longtime fire chief Earl Frye in the 1990s, after he passed away. Fire station No. 2 was opened in West Amory in 1984.

Five

THE COMMUNITY

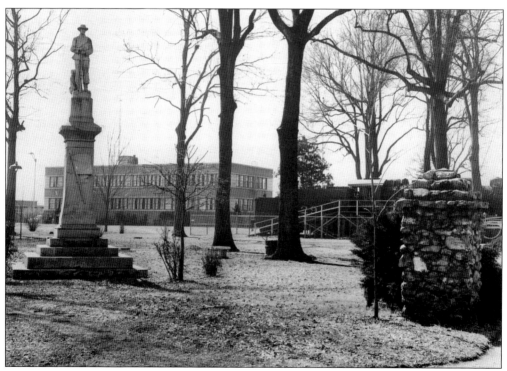

The Confederate monument, which was moved to the park from the middle of Main Street in the late 1940s, stands guard over engine No. 1529 and the new city hall in this photograph from late 1969. Frisco Park would undergo renovations as part of urban renewal, with sidewalks, a new fountain, and lighting installed. The bandstand was removed during the renovation as well. A new covered pavilion was added on the south side of the park in the 1980s. Frisco Park has been the center of social activity in Amory since the town was founded. Today, the park is the site of the annual Amory Railroad Festival, which attracts up to 60,000 visitors over a four-day period. The park is used for rallies, concerts, and other activities throughout the year.

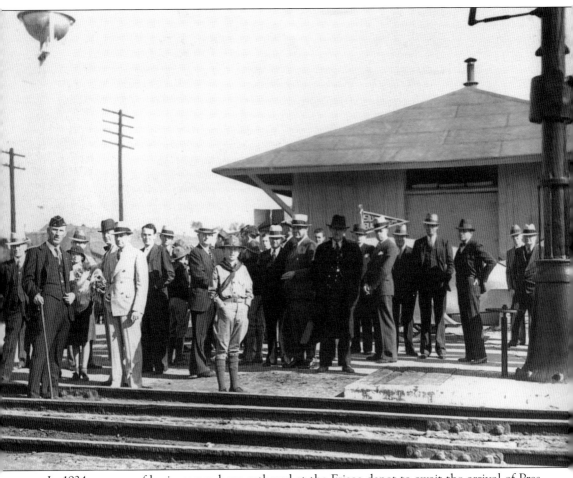

In 1934, a group of businessmen have gathered at the Frisco depot to await the arrival of Pres. Franklin Roosevelt. The president had been in Tupelo for the opening of the Tennessee Valley Authority (TVA) service and made a stop in Amory to speak.

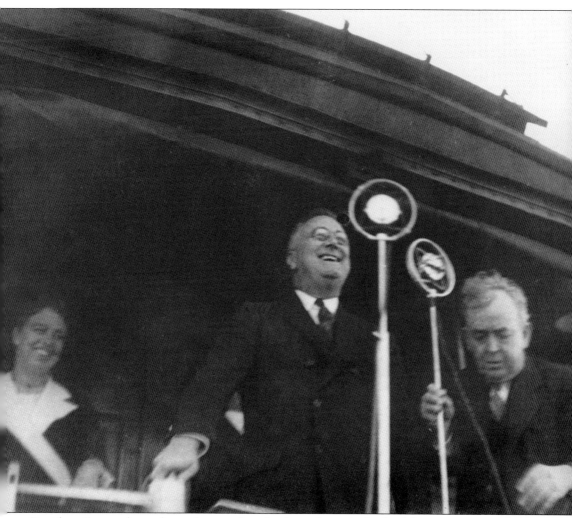

President Roosevelt speaks to the crowd at the depot from the back of the train carrying him on his return to Washington. It is estimated that a crowd of over 10,000 people gathered to see the president. On the left is First Lady Eleanor Roosevelt, and on the right is Congressman John Rankin. To date, the Roosevelts are the only sitting president and first lady to visit Amory.

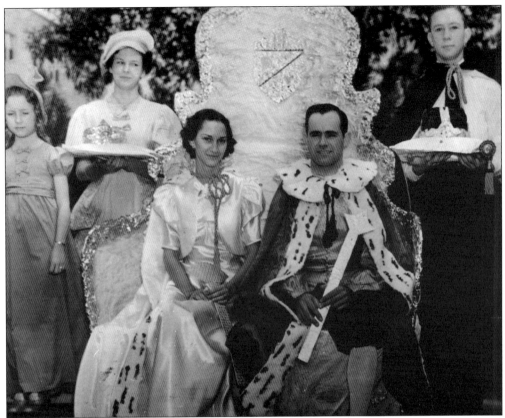

On October 23, 1937, Amory celebrated its golden jubilee. The celebration was a huge event with dances, plays, reenactments, and receptions to mark the occasion. Railroad dignitaries and government officials were also in attendance. Selected to serve as king was Tommy Harrison, and the queen was Mary Evelyn Moore. Serving on the court were Martha Dalrymple, Evelyn Gregory Millender, and J.O. Prude III.

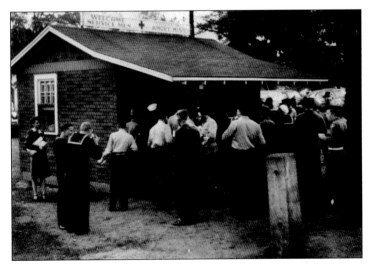

During World War II, troop trains would regularly come through Amory. The Red Cross set up a canteen to greet the servicemen and offer coffee, donuts, a warm smile, and conversation as the men took a brief respite. In 1943, servicemen are gathered at the canteen to enjoy some Southern hospitality from the young women who worked there.

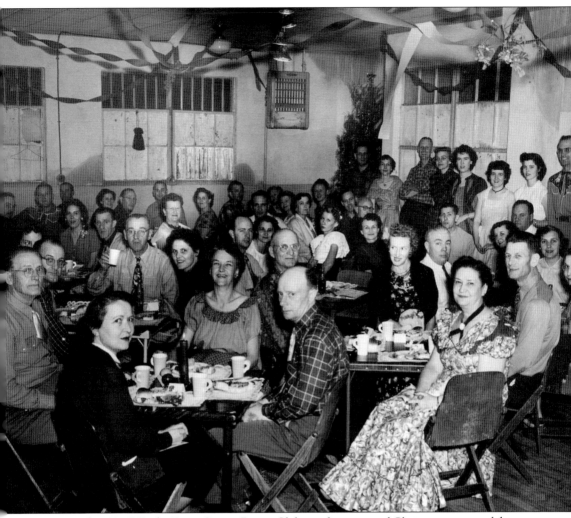

On December 20, 1952, the Frisco Square Dance Club met for its annual Christmas party and dance. Frisco employees not only worked together, most of them also enjoyed social activities together.

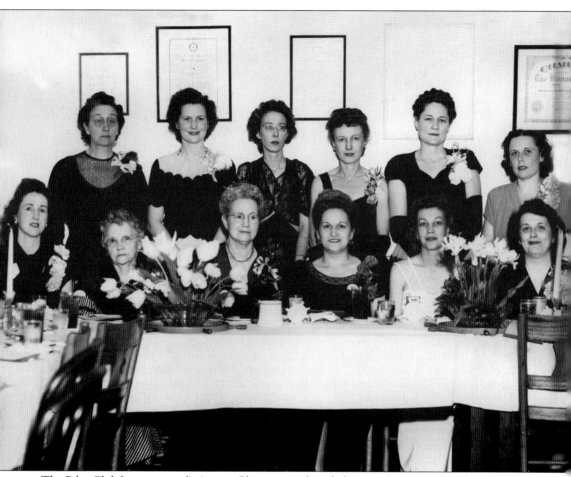

The Pilot Club International's Amory Chapter was founded in April 1947. In this photograph are the charter members of that group. From left to right are (first row) Frances Thompson, Willie Willis, Nettie Darracott, Laverne Rogers, Charlie Nell Cheek , and Virginia Noblin; (second row) Era Bryan, Pauline Miller, Ruby Mariocourt, Christine Cheek, Irene Geyer, and Evelyn Pickle.

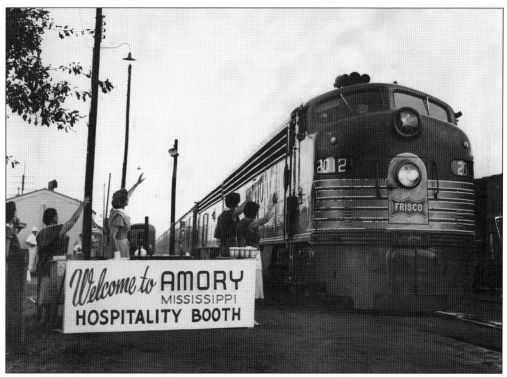

In the 1950s, June was declared Hospitality Month in Mississippi. This photograph from June 1953 shows members of the Amory Pilot Club greeting an arriving Frisco passenger train. The women would board the train and offer soft drinks and water to passengers and welcome them to Amory. The woman behind the sign is Eleanor Beckham, who served as Amory's "Miss Hospitality" for 1953. The other women in the photograph are unidentified.

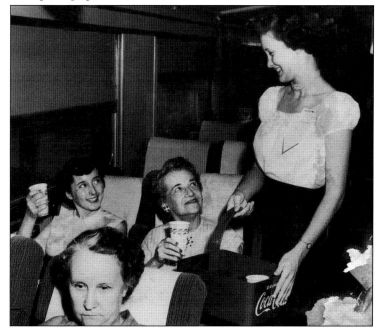

Peggy Barnett offers a refreshing drink to passengers passing through Amory in the 1950s.

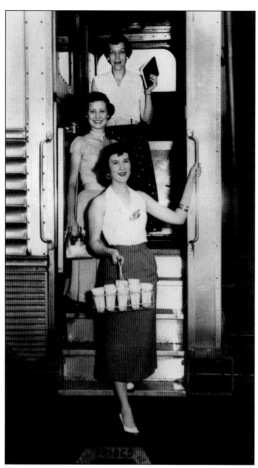

From top to bottom), Pilot Club members Charlie Nell Cheek, Peggy Barnett, and Jane Owings prepare to greet train passengers and offer refreshments during Hospitality Month.

The City of Amory hung this banner to welcome visitors for Hospitality Month in June 1954. The banner also advertised the benefits of TVA electric power. The banner was placed at the intersection of Highways 25 and 278.

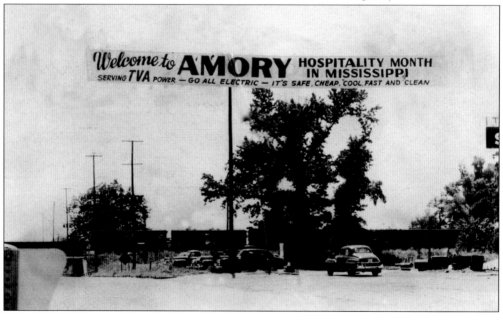

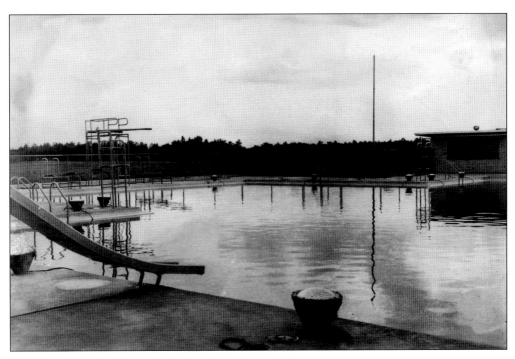

Above is the Amory municipal swimming pool on June 30, 1955, prior to its dedication and opening on July 4. The young women below are enjoying the newly opened pool in 1955. From left to right are Peggy Barnett, Martha Todd Faulkner, Barbara Pennington, Mary Ruth Noland, Jane Davidson, Joann McCary, and Lucy Leech. Because of the cost associated with needed repairs, the municipal pool was torn down in 2006.

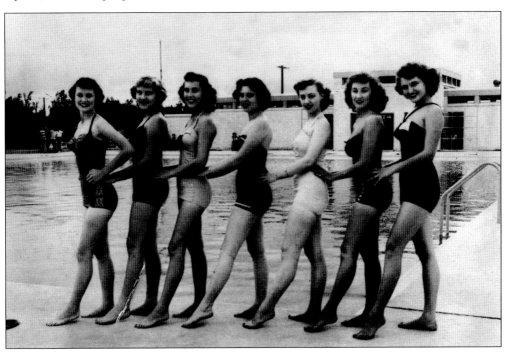

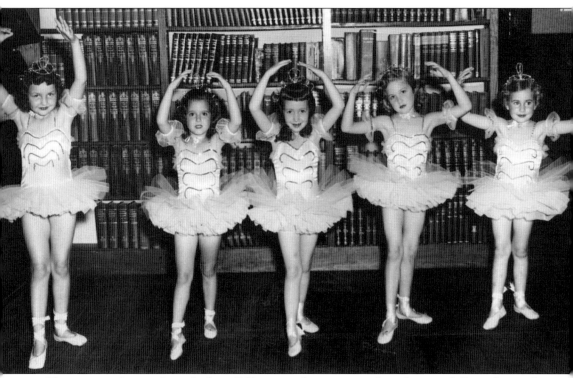

These young dancers from the late 1950s are ready to present their dancing skills at the yearly recital. From left to right are Letitia Parham, Nina Bonds, Dale Scott, Annette Cole, and Betty Sue Fowlkes.

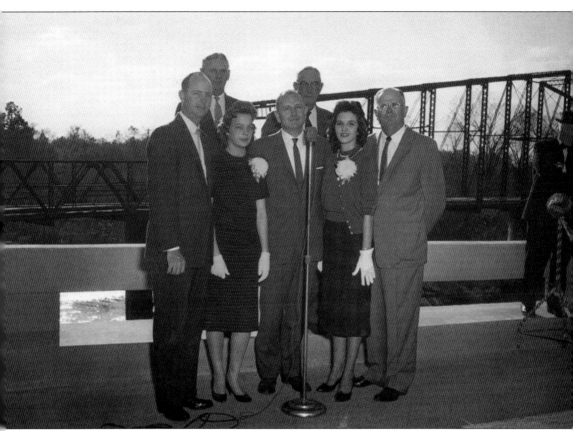

Progress came to Amory and Monroe County as new highways and bridges were completed. In this photograph from November 1959, dignitaries cut the ribbon opening the new Highway 6 Bridge at Bigbee. From left to right are (first row) Jack Norris Thomas, Jean Lee Cutcliff, Roy Adams, and two unidentified; (second row) Paul Sisk and Fletcher Miller. In the background is the old one-lane bridge, which was built in 1899 and eventually torn down in the 1970s.

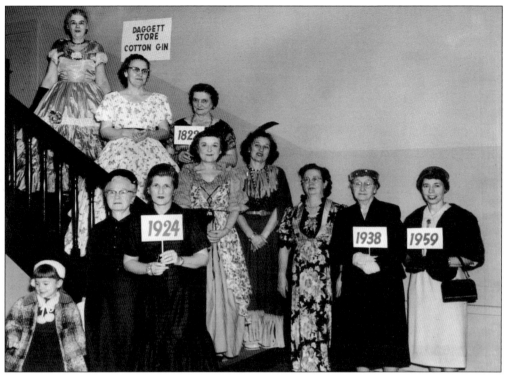

In 1959, the Delphian Literary Club of Amory presented a program entitled "Pioneer Women of Monroe County." Taking part were, from left to right, (first row) Donna Williams, Vivian Marion, and Clara Bell Moon; (second row) Vera Hood, Dana Battaile, Eva Mae Bourland, Vera Matthews, Mrs. D.T. Williams, Mary Rose Foster, and Effie Kean.

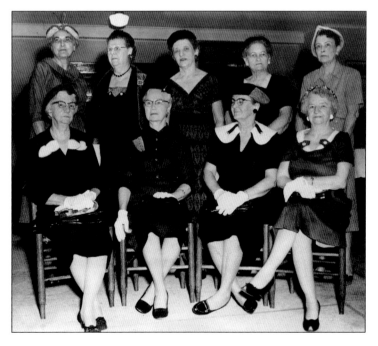

The charter members of the Delphian Literary Club posed for this photograph in 1959. The members are, from left to right, (first row) Gertrude Lea, Vivian Marion, Marie Staub, and Marie Hosmer; (second row) Rozelle Wax, Mrs. I.G. Walden, Myrtle Mayfield, Cora Roberts, and Julia Ewing.

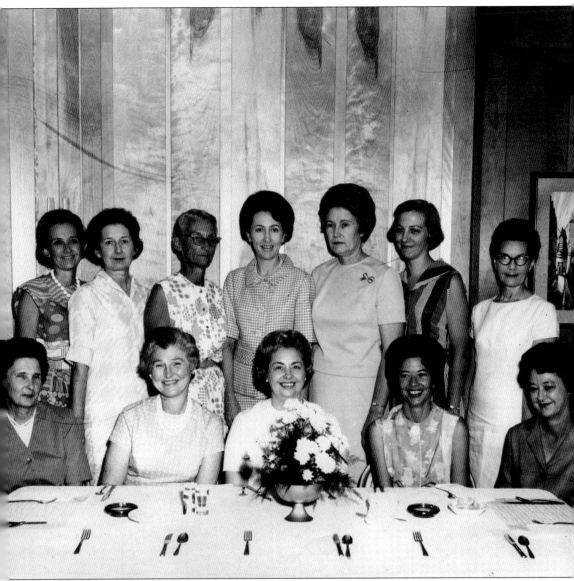

Life members and associate members of the Amory Junior Auxiliary were honored with a luncheon in 1968. From left to right are (first row) Etheline Durrett, Hyacinth Hayman, Shirley Alexander, Betty Mae Rogers, and Mable McCown; (second row) Virginia Cole, Helen Brook, Allison Hodo, Sally Prude, Sue Miller, Beckie McCullen, and Helen Kelly.

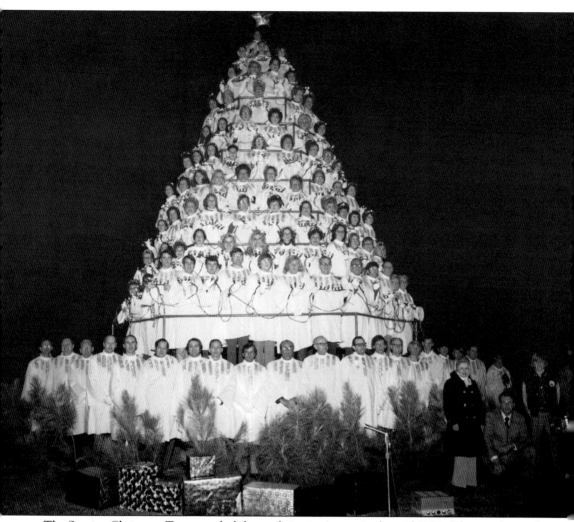
The Singing Christmas Tree was a holiday tradition in Amory in the mid-1970s. The tree featured over 100 singers and musicians. The event was held at McAlpine Lake in north Amory.

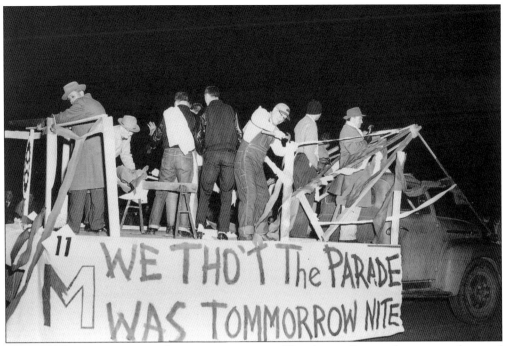

Rotary Club is an international service organization. The Amory Rotary chapter was chartered in May 1939 and continues today. In this photograph from 1959, the members of the club show a little humor with their entry in the annual Christmas parade.

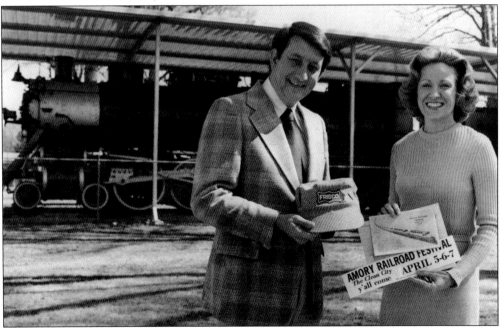

The annual Amory Railroad Festival is a highlight of the year. The festival has been named one of the top 20 tourist attractions in the Southeast and attracts over 60,000 visitors during the event. In this photograph from 1979, Mayor Thomas Griffith (left) and Mary Lib Francis, the festival chairman, announce the first festival to be held in Frisco Park.

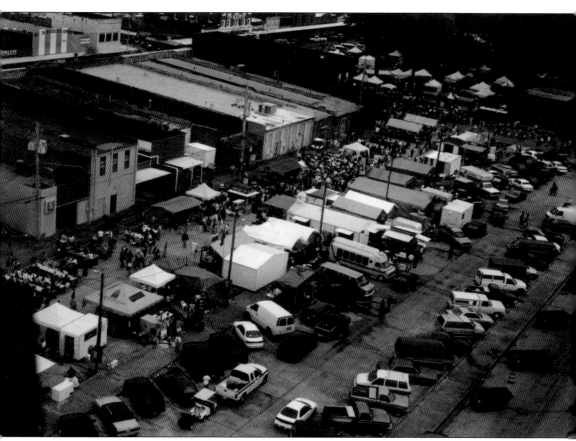

The Amory Railroad Festival has become an eagerly awaited event for people all across northeast Mississippi. The festival features arts and crafts, a food court, train rides, a carnival, live entertainment, and a car show. In 2014, the festival celebrated the 36th annual event, making it the oldest community festival in Mississippi. In this photograph from the late 1990s, the food court is busy with hungry festival patrons. At the top is Frisco Park, where the arts and crafts vendors set up shop.

Six
THE GILMORE LEGACY

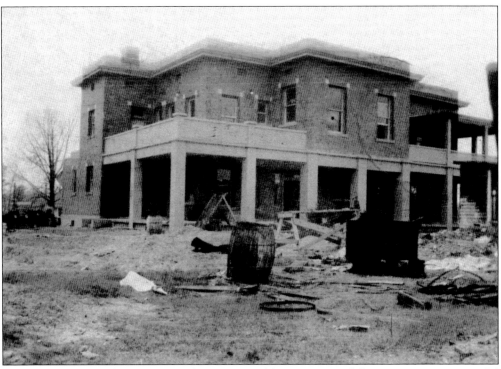

E.D. Gilmore moved to Amory in late 1887 and became one of the town's most successful businessmen and a generous philanthropist. Recognizing the need for medical care in Amory, he and his wife, Virginia, decided to build the first hospital in the area. Construction on the Gilmore Sanitarium was started in April 1916, and the hospital was opened on December 1, 1916. The Gilmore legacy remains a strong presence in Amory, and, through the generosity of the Gilmore Foundation, will last for years to come. In this photograph from the fall of 1916, construction is well underway on the new hospital. The hospital was built on five acres of land south of downtown Amory.

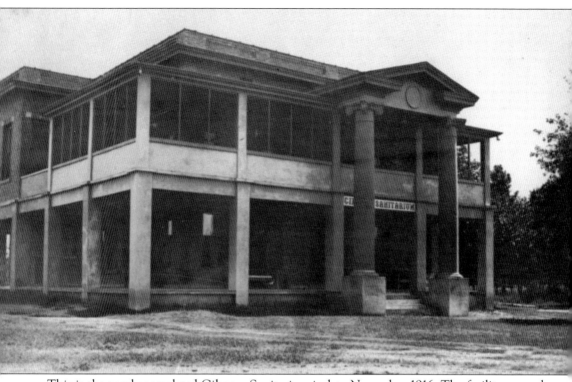

This is the nearly completed Gilmore Sanitarium in late November 1916. The facility opened on December 1 and had 20 beds for patients. The hospital was unique in that it also had a training program for nurses. The nurses lived in a house next door and worked during the day and attended classes at night. Because of E.D. Gilmore's close ties to the Methodist Church, he made arrangements for the nurses to complete their training at Emory University in Atlanta. The nursing school was closed in the early 1950s.

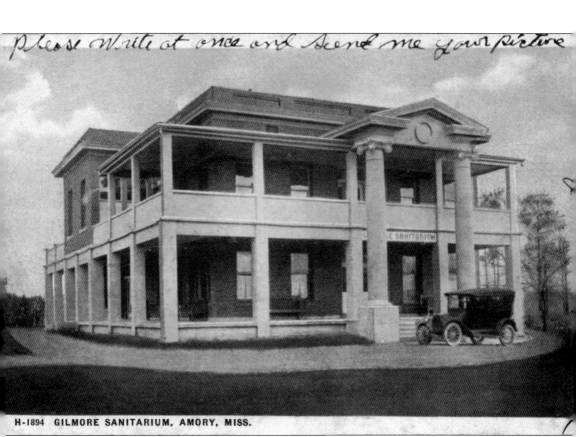

A postcard from 1918 shows the Gilmore Sanitarium as it appeared after completion. Many people have wondered why the hospital was named "sanitarium." The name was chosen by Virginia Gilmore because the definition of sanitarium is "a healthy place of healing."

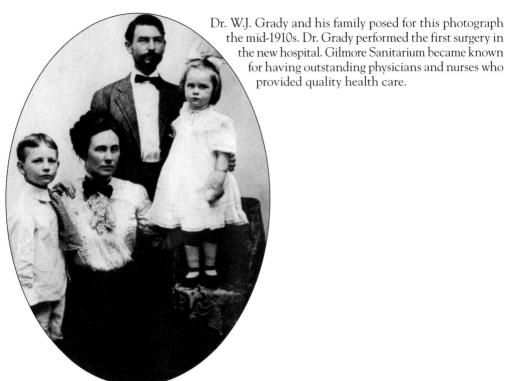

Dr. W.J. Grady and his family posed for this photograph the mid-1910s. Dr. Grady performed the first surgery in the new hospital. Gilmore Sanitarium became known for having outstanding physicians and nurses who provided quality health care.

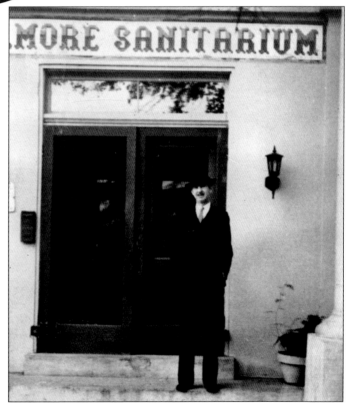

Dr. M.Q. Ewing served as the chief of staff at Gilmore Sanitarium for many years. Dr. Ewing served in the Navy during World War II and returned to the hospital after completing his service in 1945. Dr. Ewing and his family occupied a house directly across from the hospital. In this undated photograph, Dr. Ewing is shown on the front porch of the hospital. Since there was no air conditioning, all windows and doors had screens to provide cool air to the building.

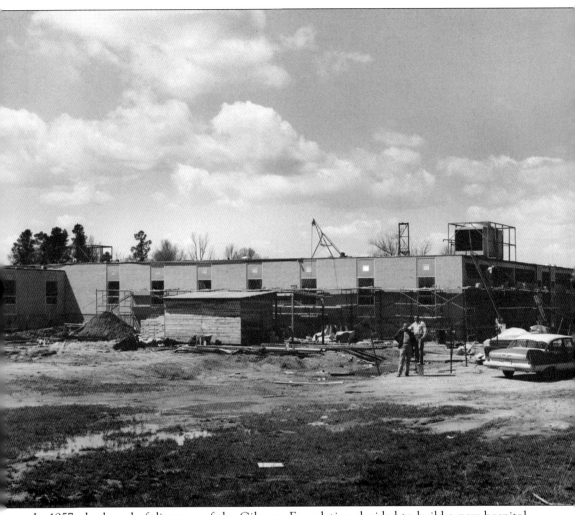

In 1957, the board of directors of the Gilmore Foundation decided to build a new hospital. Construction on Gilmore Memorial Hospital was started in 1960, and the facility opened on February 1, 1961. This photograph from 1960 shows construction well underway. Since the hospital was opened, there have been several renovations and additions.

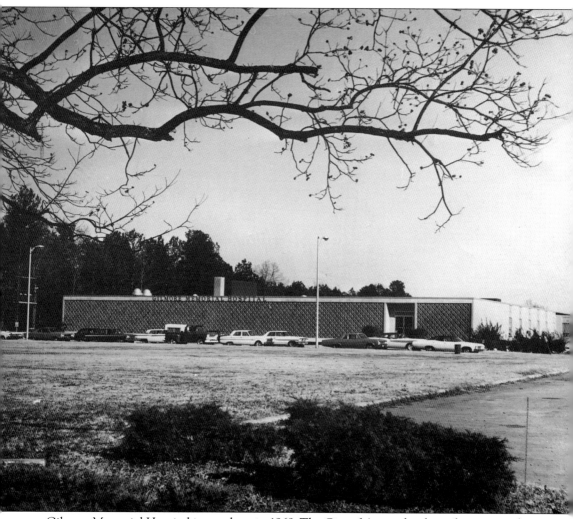

Gilmore Memorial Hospital is seen here in 1969. The City of Amory has been fortunate to have quality health care readily available to its citizens. Gilmore Memorial Hospital had 51 beds when it was opened. Through expansion, it eventually reached 105 beds. Gilmore Memorial Hospital was named in memory of E.D. and Virginia Gilmore, who brought the first hospital to Amory.

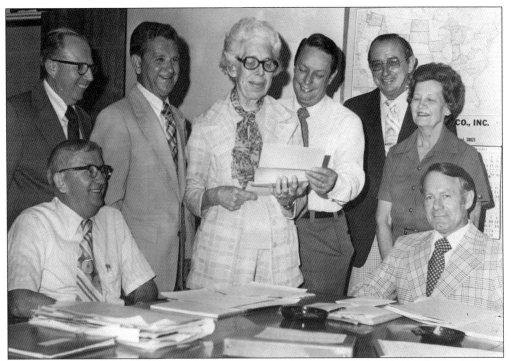

After the Gilmore Sanitarium nursing facility was closed in 1965, the building fell into disrepair. It sat empty until 1974, when the Amory Bicentennial Committee decided to open a museum as the city's bicentennial project. The Gilmore Sanitarium building was selected as the site of the museum. The Gilmore Foundation sold the building to the Amory Arts Council for $10. After raising more than $50,000 from the people of Amory for repairs and renovation, the museum was dedicated on June 27, 1976. In this photograph from 1975, city officials and members of the Amory Arts Council are making plans for the new museum. From left to right are (seated) Methody James and Regan Fikes; (standing) Carl Coggin, Henry Grady Wright, Lucille Rogers (the first museum director), Billy Glasgow, Roy Ausborn, and Warrenne Cutcliff.

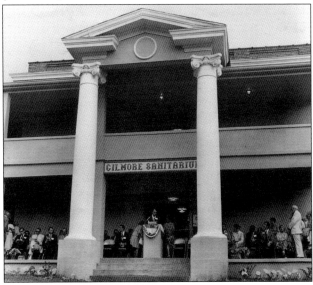

The Amory Regional Museum was dedicated and opened to the public on June 27, 1976. The special guest at the dedication was Cleveland Amory Jr., the grandson of Harcourt Amory, for whom the city was named. When the museum was opened, it was the first city-owned museum in the state of Mississippi.

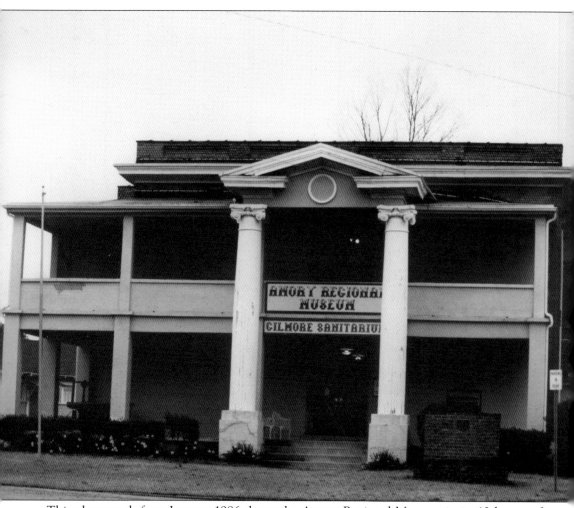

This photograph from January 1986 shows the Amory Regional Museum in its 10th year of operation. The museum is a source of pride for the citizens of Amory and welcomes over 5,000 visitors annually.

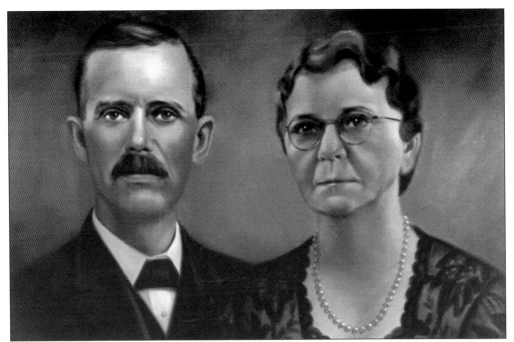

This portrait of E.D. and Virginia Bolding Gilmore hangs in the lobby of the Amory Regional Museum as a tribute to the contributions they made to the city of Amory. Mr. Gilmore passed away in 1927, and Mrs. Gilmore passed away in 1945. Their only child, E.J. Gilmore, died in 1974. In fact, the *Amory Advertiser* edition announcing the museum also included the obituary of E.J. Gilmore. The Gilmore family left a legacy that will benefit the city of Amory and Monroe County for generations to come.

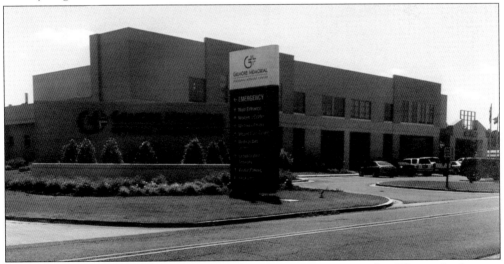

This is Gilmore Memorial Regional Medical Center as it appears today. The medical center is home to a neonatal intensive care unit, a state-of-the-art women's center, and 95 beds. The hospital has on-staff specialists in internal medicine, wound care, obstetrics, primary medicine, and orthopedics. The hospital was sold to Health Management Associates of Florida in 2004 for $42 million. This marked the first time in almost 90 years that Gilmore Hospital was not locally owned.

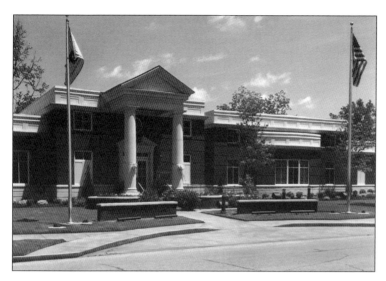

Located on Gilmore Drive in south Amory, the Gilmore Foundation Conference Center is host to meetings, receptions, and various other community functions. Located behind the conference center is the Virginia Bolding Gilmore Memorial Garden.

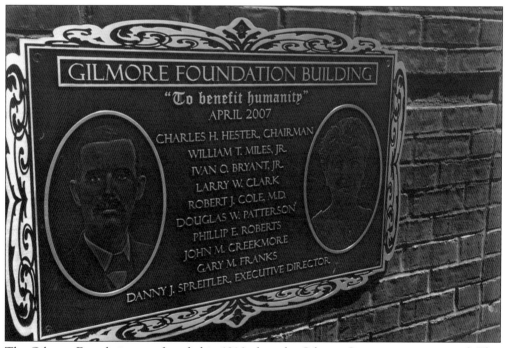

The Gilmore Foundation was founded in 1916 when the Gilmore Sanitarium was opened. This plaque on the Gilmore Foundation building shows the board of directors who were instrumental in starting and providing programs that benefit all of Monroe County. The foundation has started the Gilmore Early Learning Institute and Gilmore Promise Schools, and helped provide tuition assistance for students to attend Itawamba Community College. Today, the Gilmore Foundation continues "to benefit humanity."

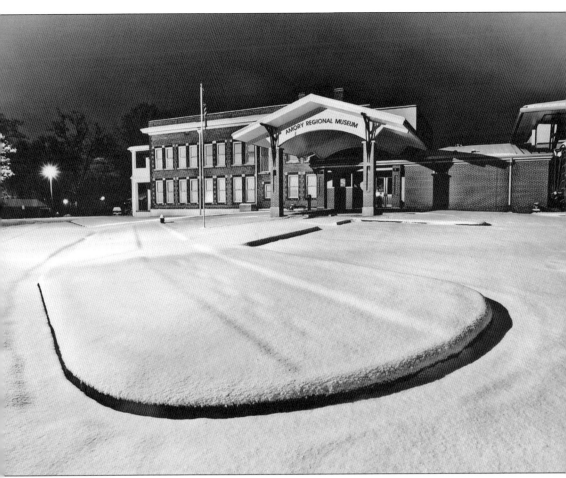

This photograph from January 10, 2011—a rare, snowy night in Mississippi—shows the Amory Regional Museum as it appears today. A major expansion in 2007 was opened to the public in 2008. The expansion included a state-of-the-art open-air gallery and train platform that provided access to the museum's railcar. The museum has hosted a wide variety of exhibits, including local art displays, exhibits from the Mississippi Museum of Art in Jackson, and Smithsonian Institution traveling exhibits. Grants and gifts from the Mississippi Department of Archives and History, the Mississippi legislature, the Effie Kean estate, BNSF Railway, the Dalrymple Family Foundation, Elnor Puckett Williams, the Amory Arts Council, the Community Bank of Mississippi, Renasant Bank, and the Gilmore Foundation made the expansion possible. (Courtesy of Parish Portrait Design.)

Discover Thousands of Local History Books
Featuring Millions of Vintage Images

Arcadia Publishing, the leading local history publisher in the United States, is committed to making history accessible and meaningful through publishing books that celebrate and preserve the heritage of America's people and places.

Find more books like this at
www.arcadiapublishing.com

Search for your hometown history, your old stomping grounds, and even your favorite sports team.

Consistent with our mission to preserve history on a local level, this book was printed in South Carolina on American-made paper and manufactured entirely in the United States. Products carrying the accredited Forest Stewardship Council (FSC) label are printed on 100 percent FSC-certified paper.